ALONG THE
MERSEY

JAN DOBRZYNSKI

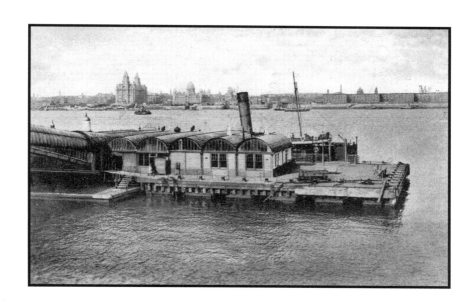

The History Press

To Mrs Phyl Pears

Title page photograph: In 1330, Edward III granted a charter for a ferry across the Mersey to Birkenhead that says 'the arm of the sea, whether for men or horses and other things whatsoever, and for the passage that shall be done in so far as reasonably receive without hindrance or impediment.'

First published 2012

The History Press
The Mill, Brimscombe Port
Stroud, Gloucestershire, GL5 2QG
www.thehistorypress.co.uk

ISBN 978 0 7524 6360 5

Typesetting and origination by The History Press
Printed in Great Britain

CONTENTS

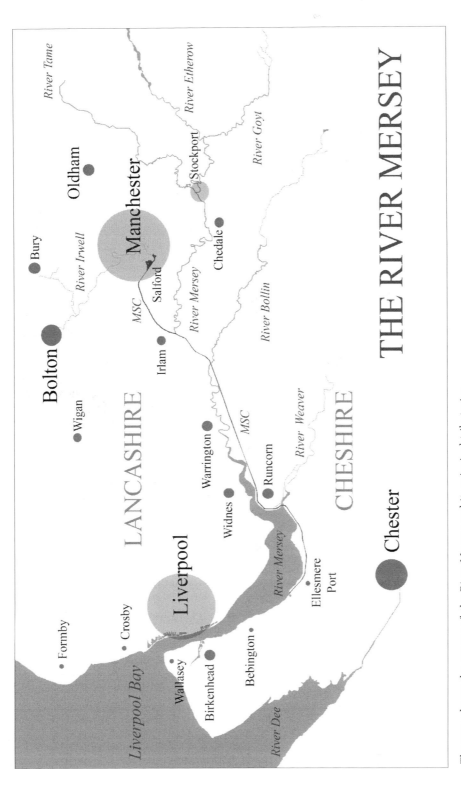

THE RIVER MERSEY

The map shows the course of the River Mersey and its principal tributaries included are the two rivers, Goyt and Tame, which combine at Stockport to form the source of the Mersey.

INTRODUCTION

The River Mersey is relatively short compared to the Severn or Thames. At just 70 miles in length, its source is at Stockport in Greater Manchester. It is born from the union of two rivers that rise in the north-west of England, the Goyt and Tame. Like the Thames, which flows through London, the Mersey serves another large English conurbation – that of Liverpool and Merseyside – and its upper reaches flow through the southern part of Greater Manchester. The combined waters of the Goyt and Etherow meet at Marple in Cheshire, once thought to be the source of the Mersey. The Mersey and Goyt for centuries has formed the natural boundary between Cheshire and Lancashire. Below Stockport, the Mersey flows in a westerly direction through Didsbury, Urmston and Flixton before it merges with the Manchester Ship Canal (MSC) and its captive river, the Irwell. The Mersey flows out of the MSC at Bollin Point as the River Bollin enters the canal. The Bollin and Irwell remain trapped in the MSC.

The MSC greatly influenced the commercial development of Manchester, to the extent that the land-locked city 40 miles inland became the third busiest port in Britain. Manchester imported cotton and grain, and exported machinery, manufactured goods and textiles from Lancashire's mills. The port was able to handle a variety of ocean-going ships, but trade began to dwindle from the early 1960s onwards and the docks closed in the 1980s. The MSC still accommodates cargo carriers and it is now under private ownership. The new owners, Peel Ports, plan to increase their shipping business by expanding the MSC and Mersey ports as part of their Atlantic Gateway Project, which will include the Port of Liverpool, Birkenhead Docks, Eastham Lock, Ellesmere Port, Runcorn and Port Salford. In the meantime, the old Manchester port at Pomona is now derelict while the Salford Docks have been redeveloped as the prestigious Salford Quays.

Free of the MSC the natural course of the Mersey passes under the M6 viaduct and over Woolston Weir. The river takes a meandering course through Woolston Eyes Nature Reserve and the southern suburbs of Warrington. Passing over Howley Weir and beside the derelict lock, the river reaches its tidal extent. A privately owned transporter bridge crosses the Mersey between two factories south of Warrington Quay railway station, the bridge an echo of the larger and more impressive Runcorn Transporter Bridge that once crossed at Runcorn Gap 6 miles further downriver. Here the tidal Mersey and the MSC flow parallel to each other with the natural river gradually expanding into its estuary until abruptly narrowed by the Widnes West Bank, where another former navigation, the Sankey Canal, joins the Mersey. The MSC and the Mersey both flow under the Runcorn road and railway bridges and the canal then passes through Runcorn Docks and Ellesmere Port to emerge into the river at Eastham Locks. The Mersey Estuary widens over a series of sandbanks and navigable channels below the confluence with the River Weaver, and the dockland waterfront of the Port of Liverpool that extends from Garston to Bootle.

By the end of the nineteenth century, Liverpool was the second most important port of the British Empire, second only to London, founded on trade to all parts of the world. A significant portion of the city's trade in the eighteenth century was African slaves and Liverpool had become the top trading port for slavery with double the combined number of slave ships of Bristol and London. The abolition of slavery made little difference to the wealth of Liverpool,

and in the following century millions of poor migrants from Ireland and Europe only added to the city's fabulous wealth. Although the port continued to grow throughout the nineteenth and early twentieth centuries, the loss of British manufacturing output from the 1960s caused the inevitable decline of Liverpool. During the 1970 and '80s, the dock estates fell silent and Liverpool lost its status as a major port. The Mersey remains a transport route for container, bulk carriers, tanker shipping, Isle of Man and Irish ferries, although the conventional docks are now defunct. In recent years, the Merseyside waterfront has been revitalised and invigorated by new industries, housing, retail, office, and leisure developments, but much remains derelict and many beautiful old buildings have been lost.

Northwards along the Wirral's east coast are Bromborough, Bebington, the extinct ferry landing stages at Eastham and New Ferry, Bromborough Pool, Port Sunlight and the Lever Brothers factory site. Further north are Rock Ferry and the reincarnated Cammell Laird shipbuilding yard, one of Britain's most famous shipbuilding names. Hidden beside the shipyard is the lost Benedictine Priory of Birkenhead, founded in 1150, granted to provide a ferry by Edward III forever – or at least until the Dissolution of the Monasteries in the early sixteenth century. The ferry became an extension of the King's Highway through Cheshire to what was then the village of Liverpool on the eastern bank of the Mersey. Sailing vessels gradually gave way to steam and the ferry routes became an essential and reliable crossing for the stage routes from Chester.

From Bootle, the Crosby Channel brings the Mersey to Liverpool Bay, and from across the estuary at the northern edge of the Wirral Peninsula is Perch Rock and the once-popular day-trippers' resort of New Brighton, once served by the Mersey ferries but also by the Mersey Railway (MR) and Wirral Railway (WR). The railways not only carried commuters and day-trippers to and from Liverpool, but also passengers to the ocean liners and steam packet ships bound for Ireland and the Isle of Man. The Great Western Railway (GWR) offered an express service to Birkenhead from the south-west of England, and a ferry or MR connection to the Pier Head. The railways and ferry crossings undoubtedly helped Wallasey develop from a group of scattered villages into a county borough and then a municipal borough with many of its inhabitants commuting daily to work in Liverpool.

At the grouping of the railways the London Midland Scottish Railway (LMS), London & North Eastern (LNER) and GWR offered their own and joint – by way of the Cheshire Lines Committee (CLC) – services to the Mersey ports and Liverpool in particular, all the lines also offering extensive goods services. From the 1930s the ports, shipbuilding trade and industry had reached a maximum extent of growth, and most started onto a long, protracted decline. It is primarily from this period of history that the majority of the images reproduced here have been taken; from the years before the more dramatic changes.

Information relating to footpaths, cycle routes and the course of the Manchester Ship Canal (MSC) are shown highlighted grey. Distances from Manchester on the MSC to Eastham on the Mersey are shown in miles. Mersey Ferries offer a daily river explorer cruise between Pier Head Liverpool, Seacombe Terminal Wallasey and Woodside Terminal Birkenhead, their six-hour MSC cruises starts from either Salford Quays in Manchester, Seacombe or Woodside on the Wirral side of the Mersey Estuary (usually between April and October). An alternative five-hour cruise on the MSC to Salford Quay starts from Telford Quay (Ellesmere Port) and the National Waterways Museum, or vice versa. Both MSC cruises to Manchester include a 2½-hour stopover at Salford Quays and a return bus journey. The photographic images included in this book are from the author's collection.

1

FROM SOURCE TO
THE RUNCORN GAP

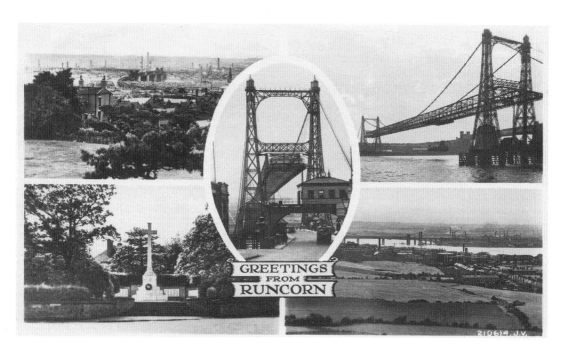

The multi-view photographic postcard above shows the Runcorn bridges across the Mersey and scenes from the town. *(Publisher Valentine & Sons, Ltd. Dundee and London)*

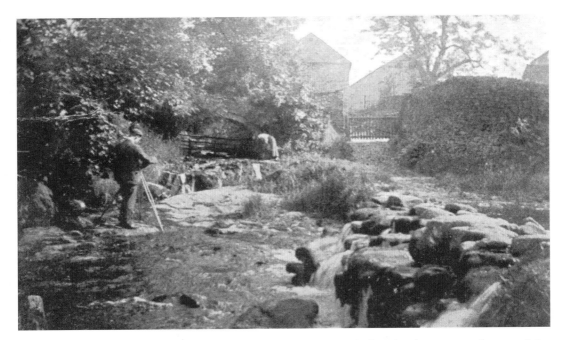

This scene shows the River Goyt between Goyt's Clough and Taxal Church. The river, a tributary of the Mersey, takes its name from an early English word 'gote', which simply means stream. The hamlet of Taxal with St James' Church lies within the boundaries of the Peak District National Park and the hamlet of Goyt's Bridge seen here was a popular destination for tourists visiting the picturesque Goyt Valley. Part of the valley is now flooded by two reservoirs, the Errwood and Fernilee reservoirs, which supply water to Stockport. Goyt's Bridge disappeared forever in the 1930s owing to a planning blight and subsequent building of Errwood reservoir dam in the late 1960s.

The Goyt again. This picturesque stretch lies east of Stockport where the waters of the River Etherow merge from the north-east.

The River Mersey is formed by the combination of the River Goyt, which flows from the south-east, and the River Tame which emerges from underneath the M60 road bridge at Stockport in Greater Manchester. Flowing almost due west, the Mersey passes through a combination of built-up urban landscapes and pleasant stretches of countryside through Cheadle and Didsbury. Passing under the M60 for the first time, it then passes under the Manchester Road B5095 Bridge at Cheadle.

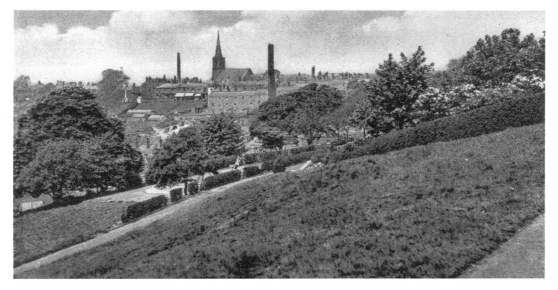

Heaton Mersey village is a suburb of Stockport. The view from the park looks down at a mixed scene of housing and industrial mills. It is here that the Mersey sheds some of its urban character as it emerges from industrialised Stockport into a more pleasant and pastoral setting. Within sight and sound of the M60, the river flows westwards.

Didsbury dates from Anglo Saxon times and it was established as a stronghold on high ground overlooking a fording point on the River Mersey. The Trans Pennine Trail and part of National Cycle Route 62 passes from West to East Didsbury along a section of the Midland railway route from Cheadle Heath to Chorlton Junction, which was closed in 1969. Tripp's Corner is typical of the suburban surroundings and lies at the intersection of Barlow Moor Road and Palatine Road, looking north.

The route of the Trans Pennine Trail, a coast-to-coast path that takes in Liverpool, Warrington, Stockport, Barnsley Selby and Hull, passes through the locality.

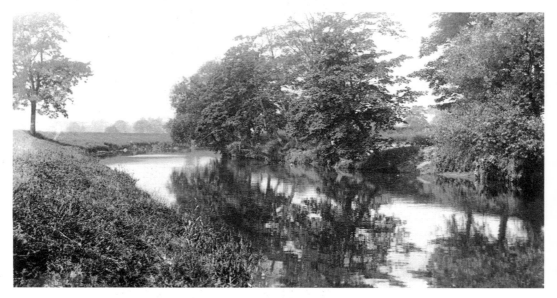

Snaking under the M60, a second time at Didsbury, the Mersey at West Didsbury is not greatly different even today. Much of this stretch of the river remains unspoilt by development or the encroachment of the suburbs of Greater Manchester.

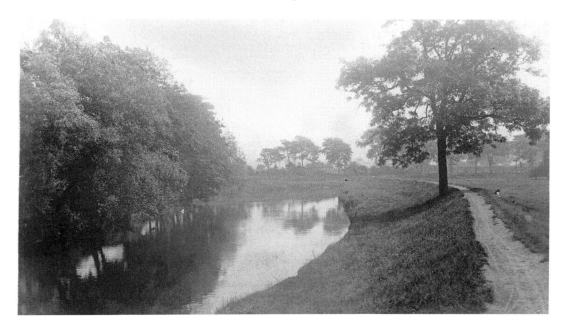

An equally picturesque riverside scene at Didsbury, where the river sweeps through a series of meanders, and where today it is crossed for a third time by the M60.

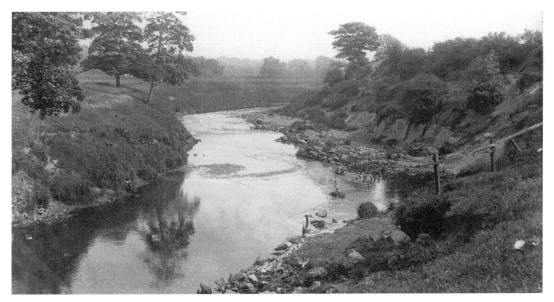

Didsbury village lies between East and West Didsbury. The riverside at West Didsbury is now a conservation area and the river here has maintained its rural character. Over recent years the Environment Agency has invested in flood defences at Stockport, Cheadle, Gatley, Northenden, Didsbury, Chorlton, Stretford, Ashton-on-Mersey, Carrington, Flixton and Irlam. At Didsbury flood levels are controlled by opening sluice gates at Fielden Park to direct floodwater onto Withington Golf Course, while similar measures are used at Sale to direct water into Sale Water Park. The water is then released in a controlled manner when the peak of the flood wave has passed.

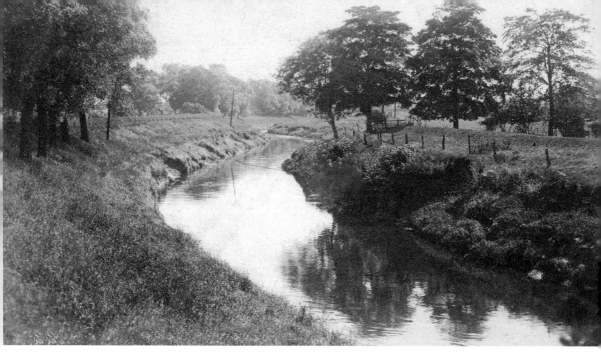

The riverside at Didsbury as it adopts a north-westerly course towards Northenden and Tatton Weir. Also between the banks of the Mersey and Stenner Woods are the Fletcher Moss Botanical Gardens donated by Alderman Moss in 1919 to the city of Manchester.

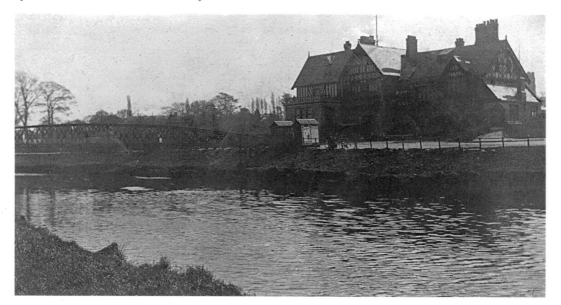

Hemmed in between two motorway bridges, the river here is far from tranquil – disturbed by the constant background hum of the M60. A sad sight today is the derelict state of the mock-Tudor Tatton Arms Inn in Boat Lane, Northenden village. The footbridge across the river is still in situ but the pub has closed and is boarded up and neglected. The riverside offers a pleasant aspect to the village, but the old pub, which in its heyday was an attractive and popular location for visitors, has now become an eyesore.

George Thomas, a prominent civil engineer, donated the grounds of Irlam Hall to Salford; they were later named Prince's Park to commemorate Edward VII's visit to Irlam in 1909. From the early eighteenth to the late nineteenth centuries, the Mersey & Irwell Navigation was a canalised river route from the Mersey Estuary to Salford. The navigation was later abandoned and the course of the natural river below Manchester was largely obliterated with the building of the MSC. The Irwell once flowed naturally through the grounds of Prince's Park to join the Mersey north of Cadishead. The park has a sunken garden and a preserved channel of the Irwell that is now a series of lakes and a natural habitat.

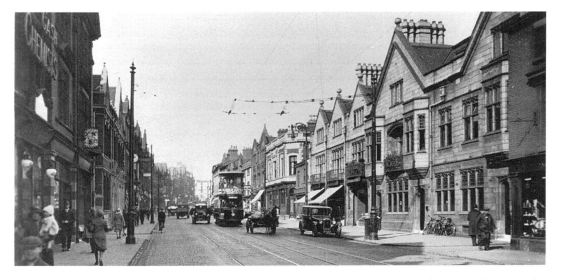

Bridge Street, Warrington. The Warrington Corporation tram is approaching the bridge and heading for Latchford on the opposite bank of the Mersey. The town was a strategic crossing point for the Romans and Saxons. A market town, it received its charter in the Middle Ages and developed as a manufacturing base for textiles, iron and soap. The Mersey & Irwell Navigation served the town from the early years of the industrial revolution and, together with the Sankey and Bridgewater canals and later the railways, they helped distribute manufactured goods and import raw materials to the developing town. Other industries such as steel wire, brewing, tanning and a chemical industry soon followed.

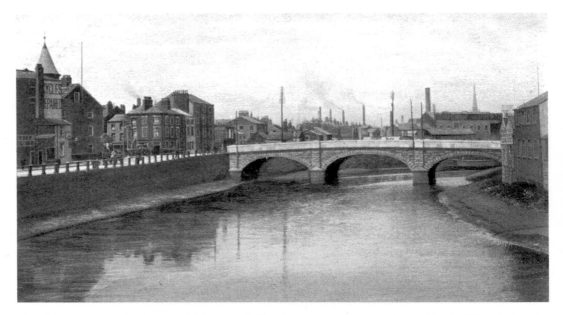

The old Warrington Bridge at which point Bridge Street meets Mersey Street. The building facing the bridge at the opposite corner of Bridge Street still stands and there is now a noticeable absence of factory chimneys on the skyline. The final modern crossing, dating from 1915, superseded the old bridge – one of a number that once stood at the same spot.

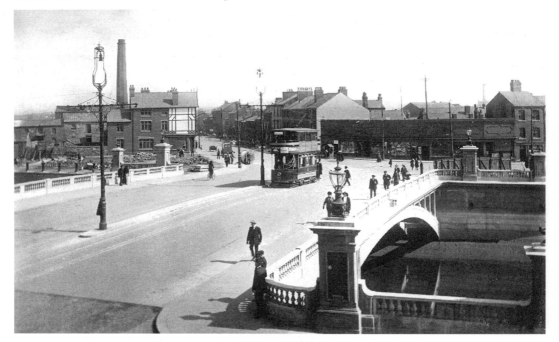

The new bridge at Warrington. In 1913, King George V unveiled the first section of the concrete rib-arched construction. The bridge is 80ft wide and is seen here shortly after it was constructed. The Warrington Corporation tram is making its way back from Latchford across the bridge heading towards the town centre.

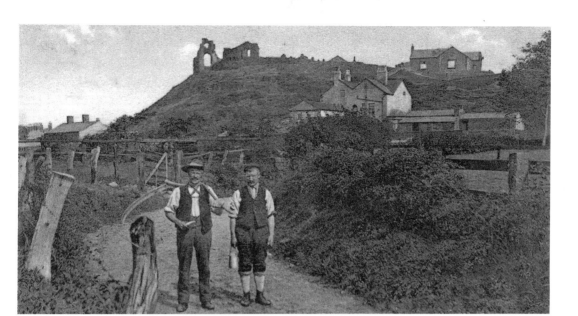

The village of Halton and the ruins of Halton Castle are now part of Runcorn. It was formerly a palatinate, which was a semi-autonomous barony under the administrative control of the Earls of Chester, established after the Norman Conquest. A succession of barons have held Halton Castle between the eleventh and the late fourteenth centuries, after which time it passed to the Duchy of Lancaster and the Crown under Henry IV. Overlooking the tidal Mersey Estuary and village, Halton Castle had seen little in the way of conflict until the Civil War when it twice came under siege. The castle fell into ruins shortly afterwards and appears very much the same today as it did in this early twentieth-century photograph.

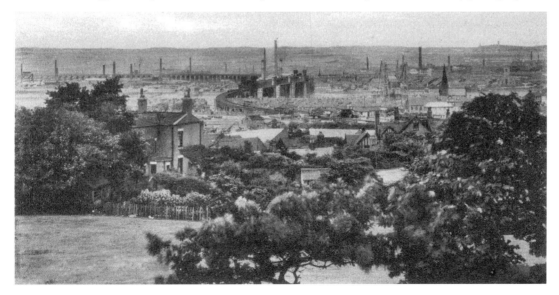

From an equally prominent spot, the view shows the bridges at Runcorn Gap looking northwards from Runcorn Hill. The present-day view now encompasses the A533 Queensway road and Silver Jubilee Bridge opened in 1961, which replaced the Transporter Bridge seen in this photograph.

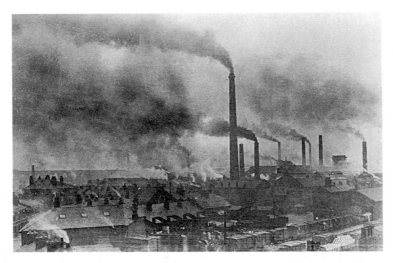

An image entitled 'The Sun Blushes at Widnes Smoke' is a reference to the smoke thrown out over the town by the billowing chimneys of chemical works. Widnes developed during the industrial revolution largely helped by the arrival of the Sankey Canal or St Helens Canal & Railway and subsequently the St Helens & Runcorn Gap Railway, which later became part of the London & North Western (L&NW). The relative ease with which raw materials and manufactured commodities could be transported led to the growth of the town's factories and housing for employees. The chemical factories produced soda ash (sodium carbonate), soap, borax, salt cake and bleaching powder.

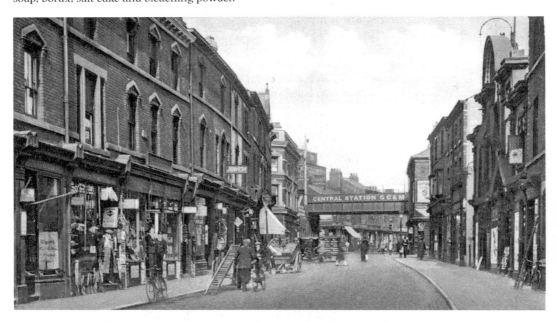

Victoria Road, Widnes. The Central station on the Great Central and Midland Committee line connected with the Cheshire Lines Committee (CLC) line between Manchester and Liverpool. The station platforms extended onto the railway bridge seen here, and both the station and bridge were swept away in the 1980s with the building of the Ashley Way A562 road. The station opened in 1879 and closed in 1964 along with the line. Further south along Victoria Road is another extant railway bridge built by the St Helens Canal & Railway (StHC&R). It was later owned by the L&NW and subsequently the London Midland & Scottish Railway (LMS) before transferring to British Railways (BR). Beside the bridge was another Widnes station, named Widnes South, which closed in 1962 although the line is still present as an echo of the above scene.

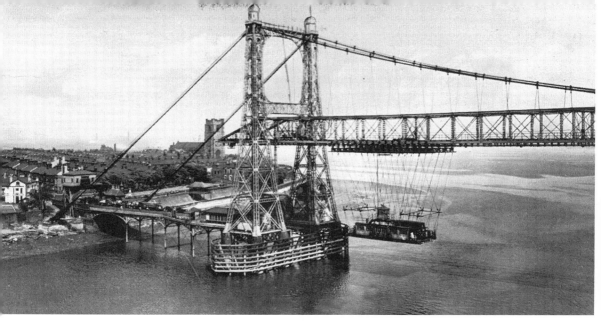

A view of the Transporter Bridge and Widnes. In the background is the sandstone-built parish church of St Mary's. The photograph was taken from the viaduct of another railway serving Widnes. The CLC and StHC&R lines mentioned previously were essentially local concerns, while the railway crossing at the Runcorn Gap is an express route from London to Liverpool originally conceived as the Grand Junction Railway (GJR) but later a constituent of the L&NW and LMS after the grouping. The Grand Junction's aim was to build a trunk line from Birmingham using parts of an existing railway to join the Liverpool & Manchester Railway (L&M).

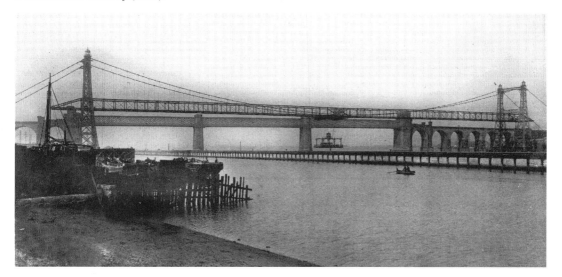

This view shows both the Transporter and Runcorn Railway Bridge crossing the Mersey at Runcorn Gap. The rowboat is on the MSC on the Runcorn side of the river.

At the Runcorn Gap, the MSC passes under the Silver Jubilee Road Bridge
and Runcorn Railway Bridge (23½ miles) in quick succession.

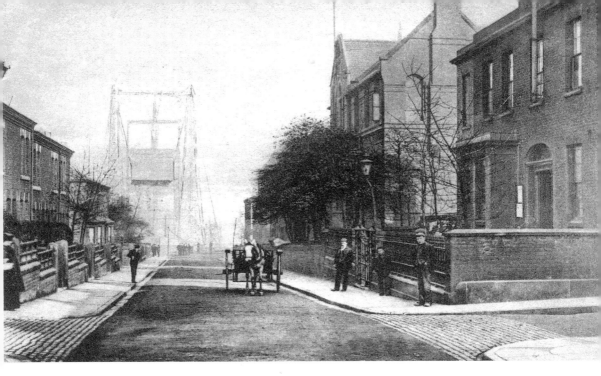

Here we see Waterloo Road, Runcorn, at the crossroads with Egerton Street, and the approach to the Transporter Bridge. Today the Waterloo Community Centre occupies the building on the right and the building beyond, built for the Technical Institute, still exists, as do the terrace houses on the left either side of Speakman Street. Ahead is the Runcorn Promenade with a ringside view of the MSC and the Silver Jubilee Bridge.

The High Street and Devonshire Place, Runcorn, from the Bridgewater Canal Bridge. Beyond is Bridgewater Street and the Transporter Bridge can be seen in the distance, as can the spire of All Saints' Church.

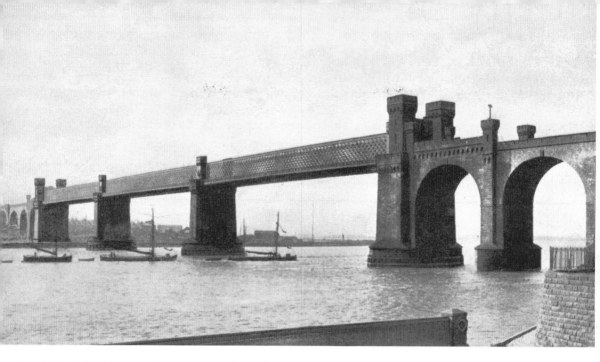

The *1876 Official Tourists Picturesque Guide* to the L&NWR described the Runcorn Bridge erected eight years earlier in detail: 'The entire length of this structure is two miles and 14 chains. The Bridge is approached by the Runcorn Viaduct, carried by thirty-three arches, one of 20 feet span, twenty-nine of forty feet span, and three of 61 feet span.' The guide adds: 'The viaduct is carried over the Mersey at a height of 80 feet, by three girders of 305 feet span each, supported on four massive castellated pillars.' This photograph of the bridge was taken from the riverside next to the Mersey Road and Mersey pub at Widnes, and it was published as an official postcard of the L&NWR.

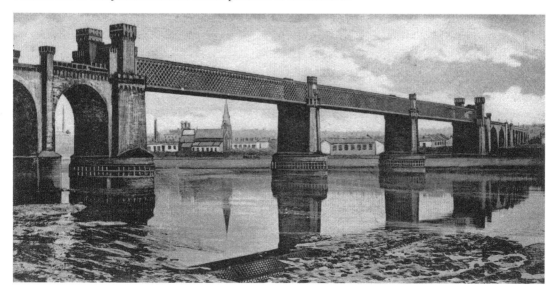

Another view of the Runcorn Railway Bridge from Widnes and Vickers Road, with the spire of All Saints' Church at Runcorn framed under the first lattice span.

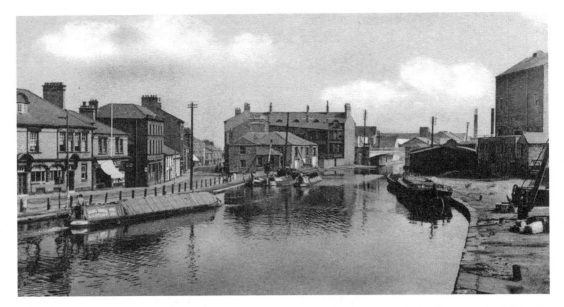

The top locks on the Bridgewater Canal beside the High Street, Runcorn. The building on the left is the Waterloo pub and the bridge in the distance passes under Devonshire Place. Today a flyover from Runcorn road bridge crosses the canal and the scene changed considerably when many buildings were demolished to make way for it. The top locks that lead to the MSC also disappeared under the Queensway Road.

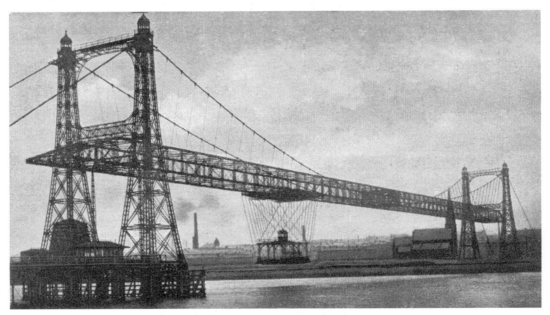

Widnes and the Runcorn Transporter Bridge. Opened by Sir John T. Brunner, Bt. and MP, 29 May 1905. The length of the span from the centre to the centre of the towers was 1,000ft, the height of the towers was 190ft above high water level and the height of bottom girder was 82ft above high water level. The girders were 18ft deep and 35ft apart. The car itself was 55ft long, 24ft wide and suspended from a trolley driven by electric motors. The crossing took approximately 2¼ minutes.

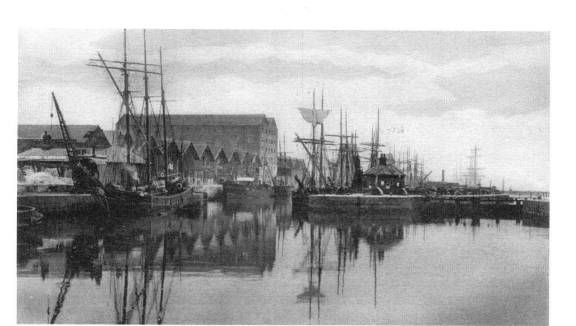

Fenton Docks at Runcorn. Coastal schooners brought cargoes of china clay, flint for transshipment on to the Trent & Mersey Canal bound for Stoke-on-Trent and the Potteries in Staffordshire, while the return cargoes where salt and chemicals from the local chemical industries based around Runcorn.

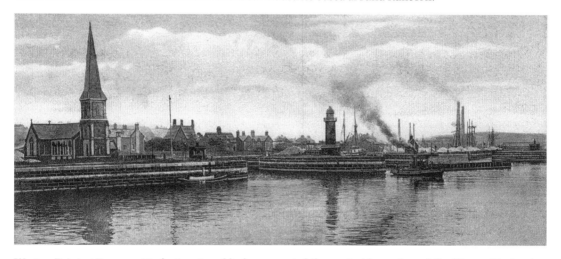

Weston Point at Runcorn Dock. A series of locks connected the navigable portion of the Weaver Navigation to the MSC, the River Weaver flowing naturally over into the MSC and through sluices into the Mersey above Frodsham Score. Today the deconsecrated Island Church, once used by sailors and boat people, stands isolated on what remains of the dock estate. The houses around the dock have been demolished, as has the lighthouse that once guided coastal river craft into the dock before the building of the MSC.

The MSC passes through Runcorn Docks and beside the blocked Bridgewater Canal
junction where the former staircase of locks once lowered the canal to the level of
MSC, passing the Bridgewater side lock (closed) on the Mersey Estuary side.

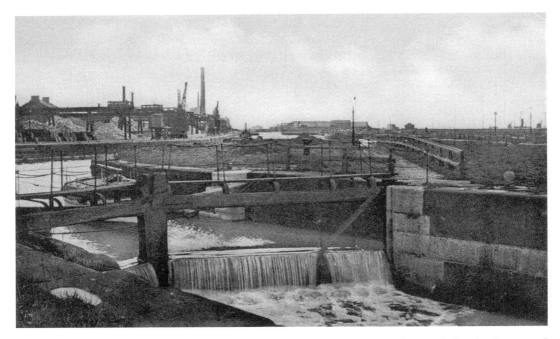

The Locks at Weston Point and the Weaver Navigation entering the MSC. The canalside wharf was used to unload flint and china clay and to load narrowboats bound for the Potteries. The Castner-Kellner Alkali Co. works, seen in the distance, made sodium hydroxide by electrolysis of aqueous sodium chloride. The port of Runcorn and Weston Point has since developed into a substantial chemical industrial complex.

This photograph was taken looking towards the south-east from the MSC at Weston Point, across the Weaver sluices and the Mersey to the Helsby Hills in the distance.

The course of the MSC passes beside Weston Mersey Side Lock (now closed), Weston Marsh Lock and the Weaver Navigation, Delamere Lock and the Weaver Sluices.

2

THE MANCHESTER
SHIP CANAL

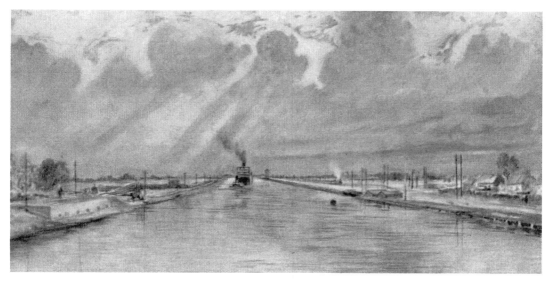

An artistic postcard view of the MSC. The 36-mile long canal opened to shipping in 1894 and was
built to take coastal and ocean-going vessels. At the time, it was the largest canalised river navigation
in the world, and allowed Manchester to avoid heavy port charges at Liverpool and transshipment costs
on the L&M railway. The MSC from Eastham follows the southern edge of the Mersey Estuary parallel
for part of the way with the M53 and M56. Passing Ellesmere Port and Stanlow Point, Runcorn and
Warrington, it continues through Irlam to Salford and Manchester to meet the
River Irwell. The Mersey joins the canal at Irlam and leaves it as the River Bollin joins it at Rixton.
(Publisher unidentified)

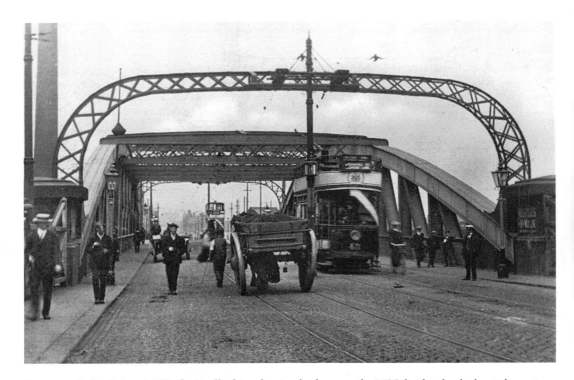

Permanently fixed since 1992, the Trafford Road swing bridge over the MSC divides the docks at the eastern terminus of the canal. A second Trafford Bridge has been built beside it, and both bridges allow small vessels to pass up the River Irwell as far as Hunts Bank. The port at Manchester developed as a series of nine docks between Salford Trafford and Central Manchester from 1894, until they closed in 1982. The upper docks numbered 1 to 5 were built on the site of Pomona Gardens (named after the Roman goddess of fruit trees and orchards). Little remains of these docks today, and the waterfront is derelict. However, No. 3 Dock has survived, since the dock connects with Pomona Lock and the Bridgewater Canal.

The River Irwell joins the canal at the head of what is the remainder of Pomona Docks. Below this is Woden Street Bridge and the entrance to the Bridgewater Canal, the Manchester Metrolink and (at 1 mile) Trafford Swing Bridge. Across the Trafford Road are Salford Quays, the Millennium Bridge, MediaCityUK Swing Bridge, Centenary Lift Bridge and the (1st lock) Mode Wheel Locks (2 miles).

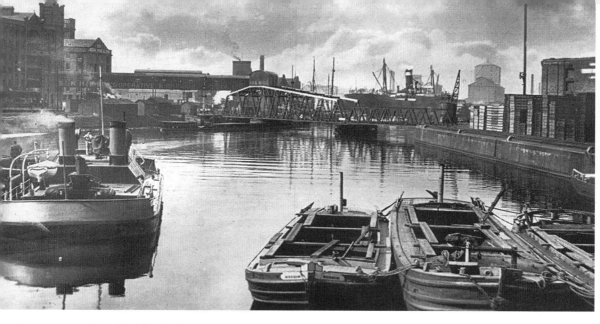

Here we see Old Trafford docks, the wharves, warehouses and railway. An extensive private standard gauge railway operated along the dock wharves and connected with the business estate of Trafford Park. The MSC Railway conveyed freight between the docks and the adjoining railway companies, principally the Lancashire & Yorkshire Railway (L&Y), L&NW and CLC. This area has been developed and rebranded as Salford Quays.

No. 8 Dock on the MSC is largely intact although the warehouses, crane gantries and railways have gone. Today the dock is at the centre of the Salford Quays development. The entrance into No. 8 Dock from the MSC has been narrowed to a pair of lock gates that divide the clean water Docks No. 7, No. 8 and No. 9 from the less pure water of the MSC.

The Salford Docks redeveloped as part of Salford Quays comprise the largest No. 9 Dock, which served the Manchester Liner fleet to Montreal, Canada. The dock has been divided into a clean water section reached by a canal from No. 8 Dock, and the lower part of the dock is still linked with the MSC. No. 7 Dock is isolated from the Manchester Ship Canal and divided into a series of separate basins. No. 6 Dock has largely remained the same and is open to the MSC.

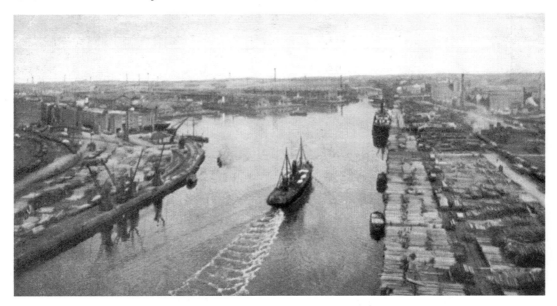

The old approach to the docks with Salford No. 9 Dock on the left and the Trafford Wharf Road on the right. The view today could be easily captured from the footbridge above the MSC connecting Media City and the Imperial War Museum. After the building of the MSC, Trafford Park had become Europe's largest industrial estate. The wharves at Trafford were crammed with large grain elevators, silos and flourmills. Grain was often used as ballast for ships carrying raw cotton from the USA.

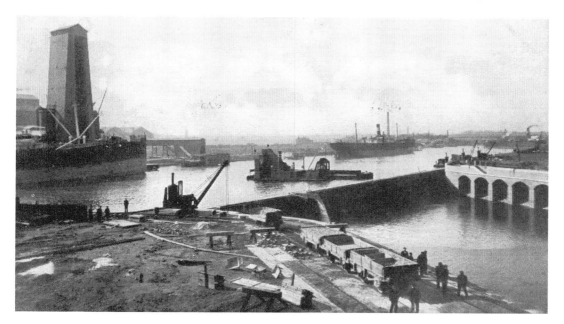

The filling of the then new No. 9 Dock, showing the position of the grain elevator and dock entrance. The dock was the last to be constructed, and it was opened at the start of the twentieth century. No. 5 Dock was in-filled from the spoil dug out during the construction of No. 9 Dock. The wooden grain silo built in 1898 opposite was at the time Europe's largest. It was destroyed during the Blitz in 1940.

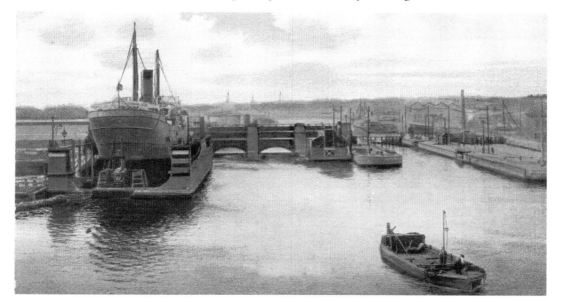

The Manchester Dry Docks Company owned three graving docks and a floating pontoon graving dock on the south side of the MSC above Mode Wheel Locks. The Mode Locks are the last set of locks before entering Salford and the port of Manchester. Three additional sets of locks lie further downstream and are of similar size. All the locks are built as a small and large parallel pair 600ft long by 65ft beam and 350ft by 45ft beam, and each has a rise of approximately 15ft. The locks at Eastham are substantially larger.

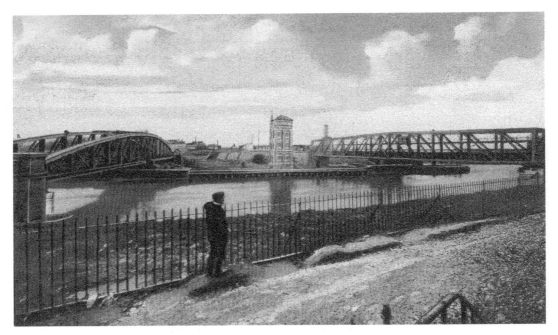

The Barton bridges, the arched road bridge is on the left and to the right is the beam-trough canal aqueduct.

Barton Swing Aqueduct (4 miles), Barton Swing Bridge, M60, Barton High Level Bridge and (2nd lock) Barton Locks (5½ miles).

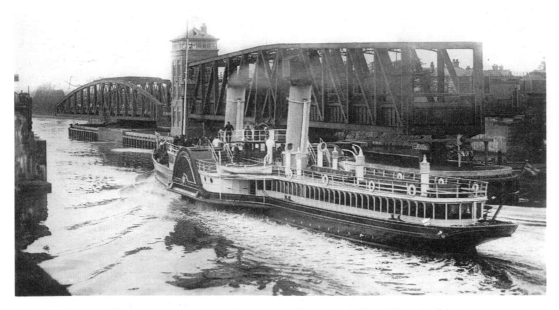

The aqueduct would swing open to allow the passage of vessels on the MSC as in this instance, giving a pleasure paddle-steamer access downstream towards the Mersey. Similarly, the Barton Road Bridge was opened at the same time to allow the vessel uninterrupted passage.

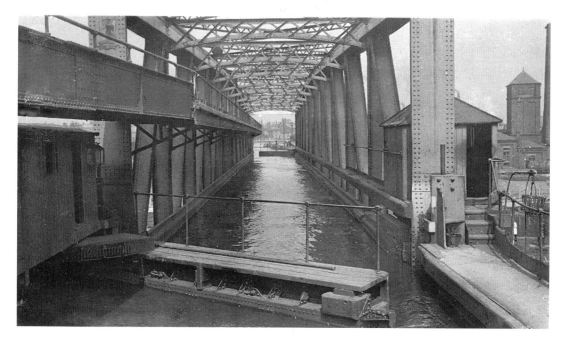

The Barton aqueduct is 235ft long, 6ft deep and 18ft wide and contains 800 tons of water when swung. It was built to carry the Bridgewater Canal across the MSC. The view is of the canal trough from a canal boat's perspective, with two sets of lock gates on the swinging section, and a matching set of two locks on each abutment closed off the canal as the bridge was opened to allow the passage of vessels on the MSC.

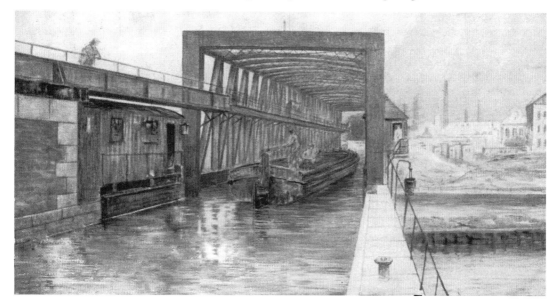

The postcard of a stylised watercolour shows a boat entering the interior of the Barton Swing Aqueduct. The Bridgewater Canal was constructed in 1760 and a stone aqueduct designed by Brindley once took it over the natural course of the River Irwell. When the MSC was built in 1894, the old viaduct was replaced. (Publisher unidentified)

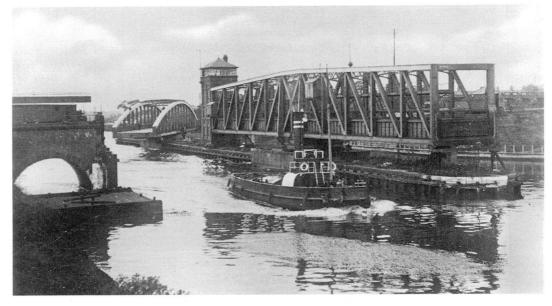

The road bridge is seen here swinging back into position across the MSC after the passage of a MSC steam tug heading upstream towards Manchester.

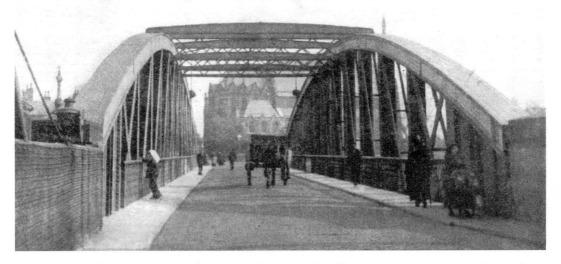

The Barton Road Bridge in its closed position allowing road traffic to once more take precedence after a vessel on the MSC had passed by.

On leaving the Barton Bridges, the MSC then flows through (3rd Lock) Irlam Locks (7½ miles) and past Irlam container barge terminal, crossing under the CLC Manchester to Liverpool railway line. The Mersey flows over a weir to join the canal beside the viaduct (8 miles). The MSC then passes under the disused Cadishead Railway Viaduct at Partington (9 miles). At Warburton, the River Bollin enters the canal and the Mersey leaves the canal. The MSC continues under the M6 Thelwall Viaduct (13 miles) beside the Woolston Guard Weir and Woolston Siphon weir.

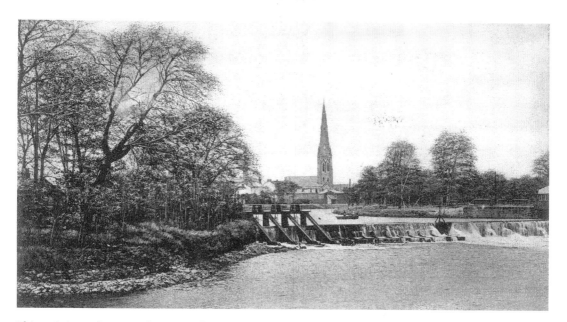

This weir is on the natural Mersey after it has left the MSC at Latchford, Warrington. Flowing freely from the MSC the Mersey passes under the M6 viaduct and over a weir at Woolston. After passing through the Woolston Eyes Nature Reserve, the river flows over Howley Weir, seen here, and beside a derelict lock. In the distance is St Elphin's, Warrington's parish church. The lock once raised vessels to riverside wharves at Woolston on a channel called the New Cut. Unlike the natural weirs on the river, the MSC utilises a series of sluices and weirs to regulate the depth of the canal – they are located at Mode Wheel Locks, Barton Locks, Irlam Locks, Latchford Locks and on the Weaver Sluices. The sluices are used to regulate excess water entering the canal and roller gates are opened automatically when the canal level rises.

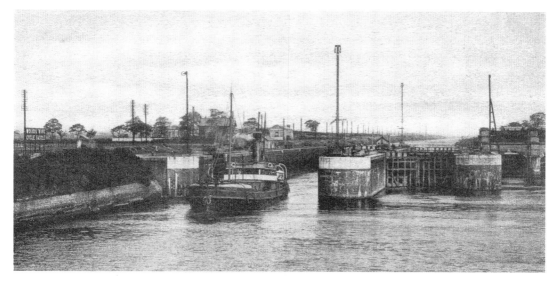

Latchford Locks on the MSC at Warrington. The larger lock is 600ft long by 65ft beam and is operational, but the smaller parallel 350ft length by 45ft beam lock is neglected and disused. Both locks have a rise of approximately 15ft.

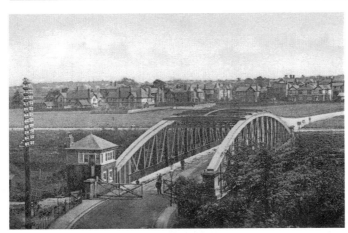

Latchford Bridge (Knutsford Road Bridge) looking down from the embankment and overbridge of the former Warrington & Stockport Railway (W&S), later L&NW and LMS. The A50 passes under the railway bridge and then over the MSC on the swing bridge shown here. Here the gates are being closed in anticipation of swinging the bridge to allow the passage of a vessel. In the distance is the clearly identifiable housing of Grappenhall and the triangle of Pilling Garden, formed by the crossing of Hunts Lane and the Knutsford Road.

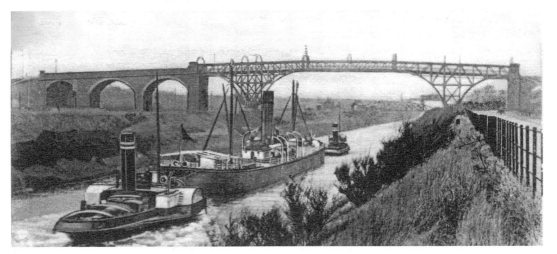

The Cantilever Bridge at Latchford, otherwise known as Latchford High Level Bridge, Warrington, is presently undergoing a facelift after looking bedraggled for some years. It was designed to cross the MSC on a 206ft span 75ft above the canal – high enough to avoid being an obstruction to navigation on the canal and to allow a constant route without interruption or closing of the road for the passage of tall vessels. It connects Ackers Road (the B5157) to Station Road and the former Latchford station closed in 1962 on the L&NWR Warrington & Stockport line.

The MSC passes under the Cantilever High Level Bridge (Latchford High Level Bridge) (16 miles), past Howley Weir, under the London Road A49 Swing Bridge and beside Walton Lock (now closed) (17 miles). It then passes under Chester Road Swing Bridge, Acton Grange Railway Viaduct (18 miles), Moore Lane Swing Bridge (19 miles) and Old Quay Swing Bridge (23 miles) and along side the Old Quay Side Lock (closed).

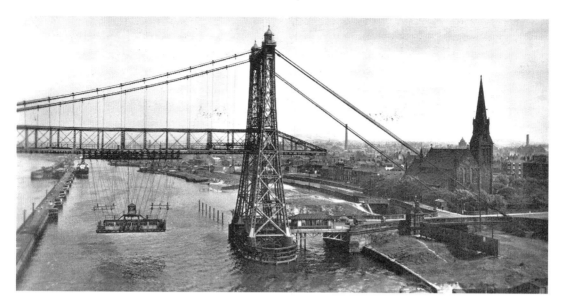

The Transporter Bridge seen from Runcorn railway viaduct and overlooking the Manchester Ship Canal.

The MSC reaches the Silver Jubilee Bridge, Runcorn Railway Bridge (23½ miles) and Runcorn Docks, Weston Mersey Side Lock (now closed), Weston Marsh Lock and the Weaver Navigation, Delamere Dock (25 miles) entrance to the Weaver Navigation and the Weaver Sluices.

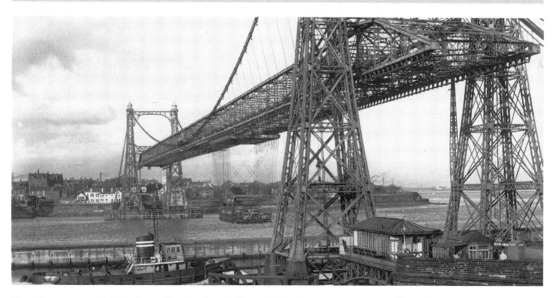

The Transporter Bridge from the banks of the MSC built in 1905. As traffic volumes increased it was unable to cope with the number of cars crossing the Mersey and it was replaced in 1961. The end of the two approach roads that connected the bridge can be traced on the banks of the estuary – a 320ft approach at Widnes and a 470ft approach road on the Runcorn side led to the 55ft by 24ft suspended car. The car was capable of carrying four two-horse wagons and 300 passengers and was suspended by an electrically operated trolley fed from a generator powerhouse on the Widnes side of the estuary.

The approach to Eastham Locks and the Mersey. The difference in height between the terminal docks at Manchester and the Mersey above sea level is 60ft, and the journey along the canal from Eastham required ships to rise to this level by a series of locks. The entrance locks from the Mersey at Eastham are larger than the other four at Latchford in Warrington, Irlam, Barton (near Eccles) and Mode Wheel at Salford. The lock at Eastham is tidal and closes the canal off from the Mersey. It measures 600ft long by 80ft beam, while the smaller lock is 350ft long by 50ft beam.

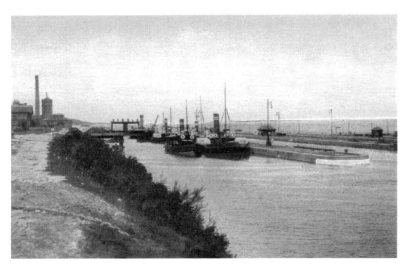

Tugboats at Eastham Locks mark the start or the end of the MSC and beyond them is the entrance from the Mersey Estuary. Coastal schooners and tall ships could not navigate the MSC above Runcorn. Their masts were unable to pass under the Runcorn Railway Bridge therefore sailing ship access was restricted to the lower reaches of the canal as far as Runcorn Docks.

This length of the MSC passes Stanlow Point and Stanlow oil depot. The Shropshire Union Canal enters the MSC at Ellesmere Port (33 miles). This is also the location of the National Waterways Museum. (5th and final lock) Eastham Locks and the River Mersey are at 36 miles.

3

ELLESMERE PORT
TO BIRKENHEAD

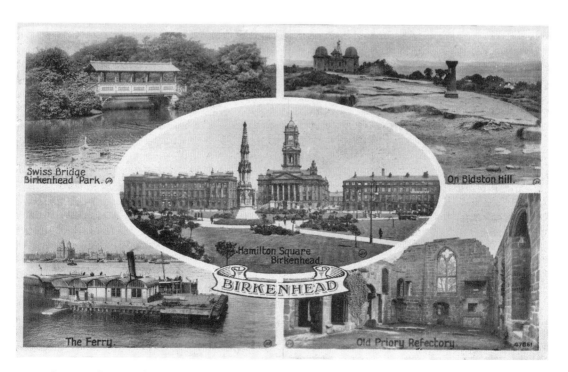

A multi-view photographic postcard of scenes around Birkenhead and at its centre is Hamilton Square.
(Publisher Valentine & Sons, Ltd. Dundee and London)

An ambitious canal proposal to join the Mersey, Dee and Severn was approved by Parliament in 1793. Engineered by William Jessop and Thomas Telford, the Ellesmere Canal succeeded in joining the Mersey at Netherpool, which later developed as Ellesmere Port, but failed to connect with the Severn. The busy canal port and later the MSC brought increased trade, which greatly attracted other industries to the area. In particular, the chemical industry, Stanlow oil refinery in the 1920s and the Vauxhall car manufacturing plant in the early 1960s. In more recent years it has attracted tourism, with venues such as the National Waterways Museum, Blue Planet Aquarium and retail shopping at Cheshire Oaks Retail Outlet. The New Whitby Road at Ellesmere Port, seen here at the beginning of the twentieth century, was a semi-rural road leading southwards from the outskirts of the town it has since become a ribbon development of housing and shops extending southwards along the A5032 towards Chester.

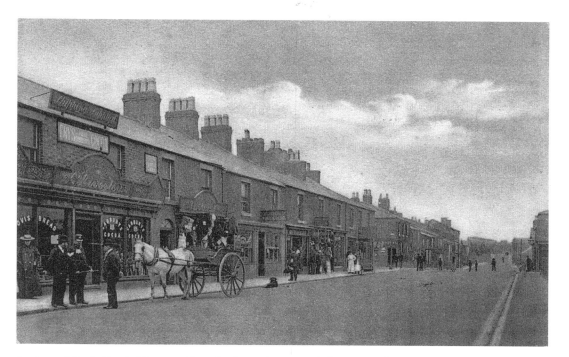

A view of Dock Street, Ellesmere Port, in the early years of the twentieth century. None of this scene is recognisable today, as it has largely disappeared under the M53. The Dock Road still exists in part between the eastbound motorway slip roads and the A5032 underpass, along with two notable buildings – the Grade II listed Century House which housed the former dock office for the MSC, and the nearby Horse & Jockey pub. The terraced houses and shops disappeared in the late 1950s when the canal basins closed and many nearby dock buildings were demolished. Much has now been redeveloped as the Canal Village housing development around the former dock and canal basin, which is home to the National Waterways Museum.

Opposite: Station Road at Ellesmere Port from the station forecourt of the former GWR & L&NW Joint Helsby to Hooton line would be just as familiar to today's railway travellers using Ellesmere Port station. The Railway Hotel on the right looks little changed since this photograph was taken shortly after 1912, although the edge of the station forecourt from where the photographer stood no longer connects directly to Station Road and the main thoroughfare through the town. Instead, the station forecourt connects with a one-way road along Europa Way and Cook Street. The area immediately to the left of the picture is now taken up with the widened A5032 road bridge over the railway line. The crossroads at Meadow Lane and Westminster Road can be seen further along Station Road which once joined with Dock Street and crossed the Shropshire Union Canal at South Pier Road above the canal basin. In the far distance today would be the underpass and slip roads from the M53, which dramatically dissects the town from the port.

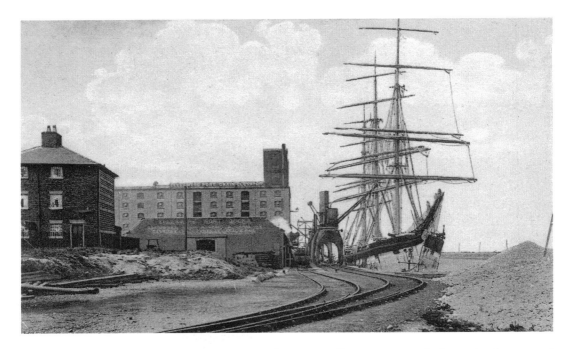

This schooner is moored at the North Quay on the MSC at Ellesmere Port with the grain elevator and warehouse in the background. The house on the left belonged to the dock manager and stood at the end of the aptly named Mersey Street, where other company houses once stood. This whole area has now become a potential brownfield development site for housing and leisure facilities, while the old docks and Shropshire Union Canal basin has been designated a conservation area.

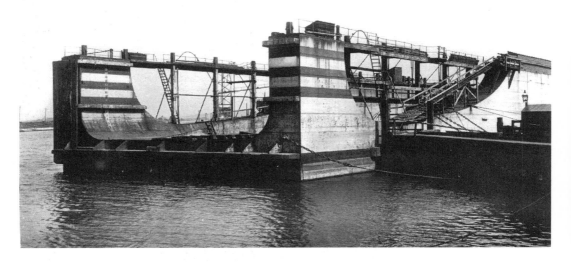

The floating graving dock at Ellesmere contained 60,000 square yards of dock area.

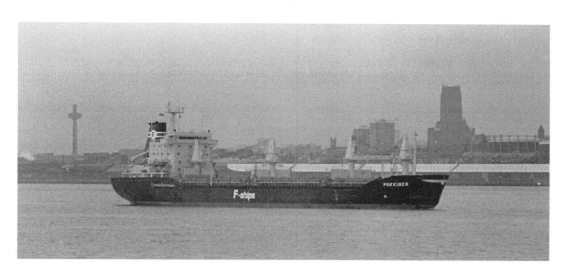

A view of the Mersey and a tanker bound for Stanlow. In the background is the Liverpool skyline with the easily recognisable tower of Liverpool Anglican Cathedral and the equally recognisable 452ft tall Radio City Tower (St John's Beacon), opened in 1969. Stanlow Oil Dock opened in the 1920s for Royal Dutch Shell to import oil to refine at their nearby petrochemicals plant. A second dock was built in 1933 and extended in the late 1940s. From the 1970s, crude oil was transported by pipeline from larger tankers moored at Amlwch in Anglesey, but the pipeline closed in the 1980s. Oil tankers now offload crude oil to a pipeline at the Sloyne, Tranmere, 10 miles further up the Mersey, which is then pumped to storage tanks at Stanlow. The Tranmere Oil Terminal opened in 1960 to handle vessels of up to 65,000 tons and the Mersey Docks and Harbour Board operate it. The refinery at Stanlow, which is now owned by Indian conglomerate Essar Energy, continues to produce a range of petrochemical products including petrol and aircraft kerosene, distributing 50 per cent by road, 30 per cent by pipeline and 20 per cent by tanker along the MSC.

The tanker shepherded by a Mersey tugboat passes the tidal lock gates at Bromborough. These gates have now been lost along with Bromborough dock, which has disappeared under landfill. The oil terminal at Tranmere for larger tonnage vessels serving Stanlow has prospered, as has the port at Stanlow and the 3-square mile petrochemicals complex.

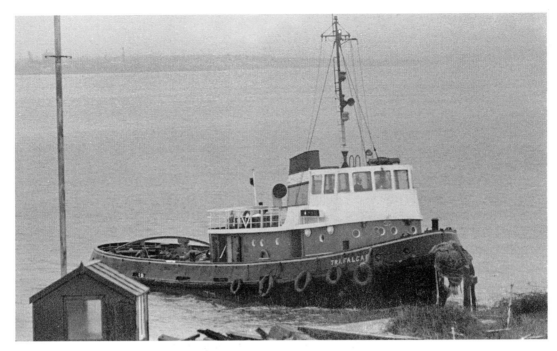

The Mersey tugboat *Trafalgar* approaching the shore at Bromborough in the mid-1980s when the port was in decline but still open to commercial traffic.

The Bromborough dock gates from the riverside, beyond which lay the dock and wharves.

The stern of the *Essi Anne* moored on the quayside at Bromborough. She was built in 1972 in the Gdynia shipyards of Poland.

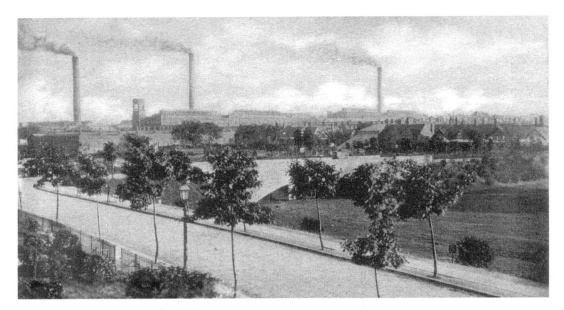

The Port Sunlight factory looking south from Corniche Road. The Lever Brothers factory was set up in 1889 by William Hesketh Lever (1851–1925) and his brother James Darcy Lever (1854–1910). The brothers were born in Bolton and the family made a living from a wholesale grocery business. The brothers diversified into the manufacture and supply of soap, formulated by a local chemist William Hough Watson. Their small manufacturing business in Warrington expanded rapidly and the brothers and W.H. Watson partnership moved to a new factory beside the Mersey near Bebington in Cheshire. The business merged with Margarine Unie in 1930 to form Unilever, which continues to be a major manufacturer and employer in the area.

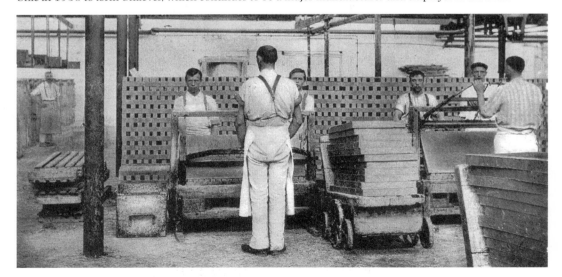

Early twentieth-century workers at the Lever Brothers soap factory at Port Sunlight operating the cutting frames. Cutting the soap to a manageable size was an important innovation and the success of Sun Light Soap was due in part to the introduction of individually wrapped smaller packets of soap as opposed to large, unbranded blocks. The ingredients, glycerine and imported palm oil (instead of fat), and clever advertising, branding and marketing ensured the company's success.

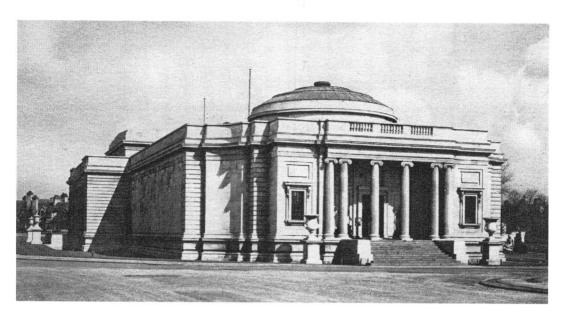

William and Segart Owen designed the Lady Lever Art Gallery for William H. Lever. The gallery was built to commemorate Sir William Lever's wife Elizabeth who died in 1913. William was made Baron Leverhulme of Bolton-le-Moors in 1917 and Viscount Leverhulme of the Western Isles in 1922. The gallery was completed in 1922 and houses an extensive collection of pottery, sculpture and paintings. It includes some of the finest examples of paintings by such artists as Constable, Gainsborough, Holman Hunt, Burne-Jones, Millais, Reynolds, Rossetti, Sargent, Stubbs, Turner and Waterhouse.

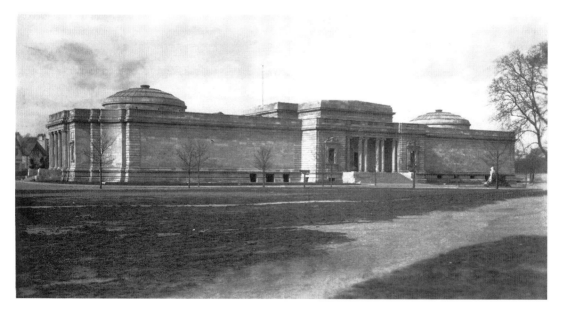

At the heart of Port Sunlight village the gallery's impressive side elevation and squat form blends unobtrusively with the surrounding houses of different architectural styles. The gallery houses much of Lever's personal collection and attracts visitors from around the world.

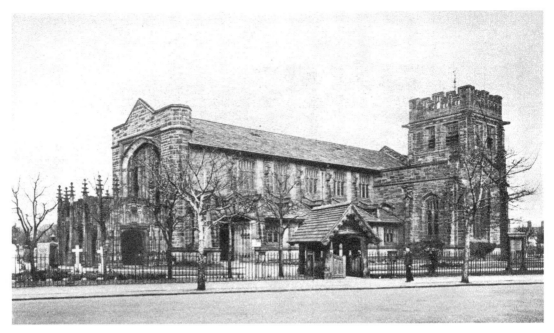

Christ Church, Port Sunlight, was another memorial commissioned by W.H. Lever – this time for his parents. Designed by William and Segar Owen and built of Helsby sandstone, the church was completed in 1904 as a non-denominational Christian church in line with Nonconformist doctrine.

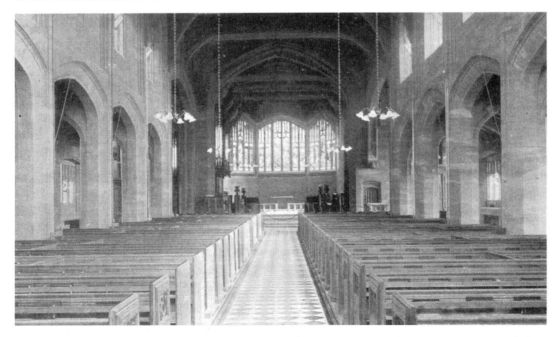

The interior of Christ Church United Reformed Church. The church, with its impressive stained-glass windows, stands on Church Drive to the north-east of the Causeway, partially encircled by King Edward's Drive, a pleasant tree-lined crescent.

The Parsonage opposite the bowling green. Port Sunlight Village and Works Bowling Club was formed by the amalgamation of the Men's Club (1905) and the Works Club (1928). Above the green is the Lyceum building, a former school, and the village social club.

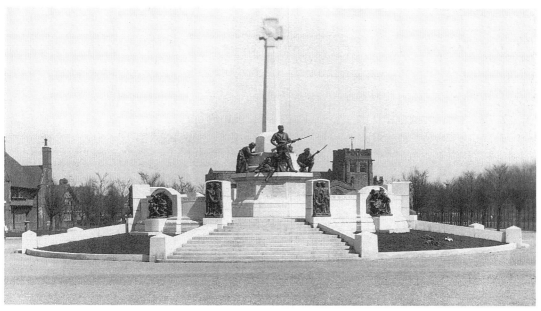

Located at the Diamond at the centre of the Causeway is Port Sunlight's War Memorial, designed by W. Goscombe John and erected in 1921.

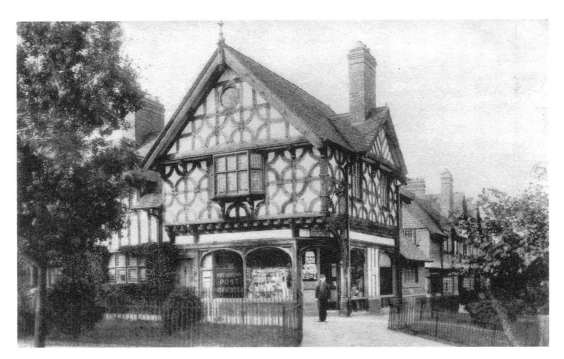

The post office is now the Tudor Rose Tea Rooms at the corner of Greendale Road, opposite the entrance to Port Sunlight railway station on the Mersey Travel Wirral Line. The Tea Rooms are open daily, from 10.00 a.m. to 5.00 p.m.

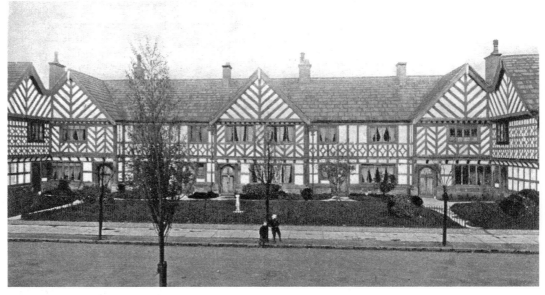

Differences in the style of the houses are most noticeable along Greendale Road, which runs practically the length of the village. Styles include English Cottage Vernacular using red brick and partly stucco, stone dressed, and these half-timbered mock-Tudor houses, which are halfway along Greendale Road between Windy Bank and Bebington Road.

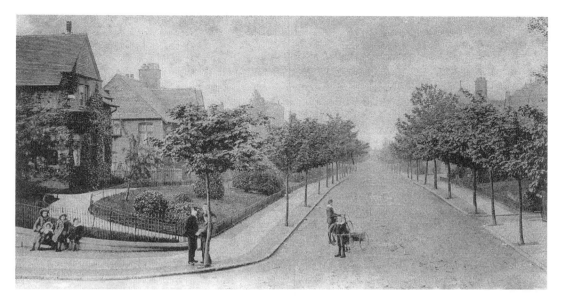

Port Sunlight Village was the creation of William Hesketh Lever, whose vision was to provide a standard of housing for his workforce in which they could live and be comfortable. Bolton Road at the junction with Greendale Road is typical with semi-detached houses (and a few detached houses built for managers) with gardens back and front built a minimum of 15ft from the roadside and with nearby open spaces for recreation.

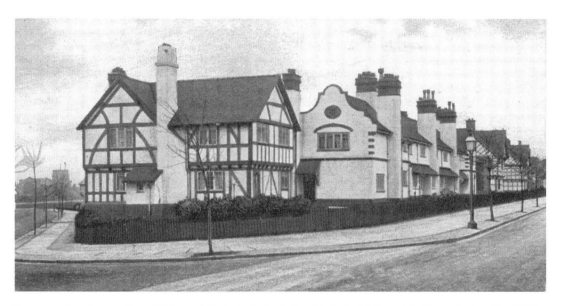

Lever employed more than thirty architects to help design his industrial model village during the 1890s. The village consists of a low-density mixture of semi-detached buildings of different architectural and period styles. The early stage of the building extended from Bolton Road, Wood Street and Greendale Road around a tidal inlet. A more formal style was adopted utilising blocks along Bebington Road, New Chester Road and front-facing buildings further along Greendale Road. The creation of outward-facing blocks and corner blocks of adjoining houses all of different design enclosed the inner garden and utilitarian spaces.

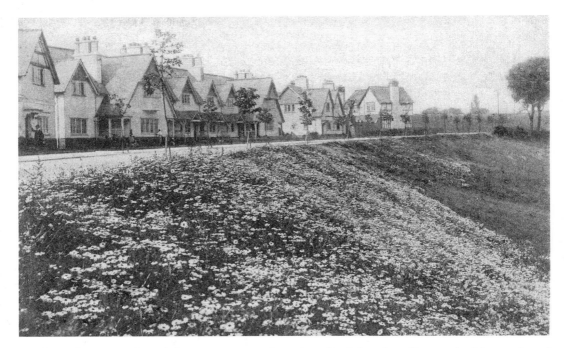

Windy Bank was proclaimed the prettiest wayside in Port Sunlight. The village evolved into a formal plan as a result of a design competition won by Ernest Prestwich (1889–1977) who at the time of his commission in 1910 was a third-year student in the Department of Civic Design at Liverpool University. The final design for the village adopted a formal regular symmetry around the Diamond.

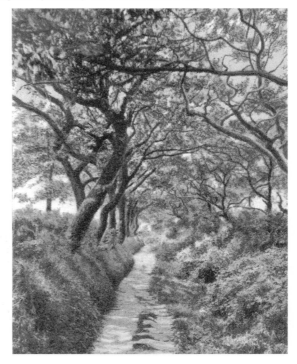

The Roman road at Bebington ran partly along what is now Kirket Lane, and was used to transport stone from Storeton quarries – known for discoveries of fossilised dinosaur footprints. However, there is no evidence that the track seen here had any true Roman connections, although it was certainly an ancient route. The church of St Andrew is built of Storeton sandstone, as are other buildings in Bebington. From the nineteenth century, stone was quarried here on a large scale. Quarried stone blocks were moved on a tramway to the quayside at Bromborough for transport across the Mersey. Storeton stone was used in the construction of Birkenhead Town Hall in Hamilton Square as well as the Sankey Viaduct in Cheshire. After the closure and infilling of the quarry with spoil from the excavation of the Mersey Queensway Tunnel in the 1920s, both the tramway and the Roman road disappeared practically without trace under the urban expansion of Upper Bebington and the woods on Storeton Hill.

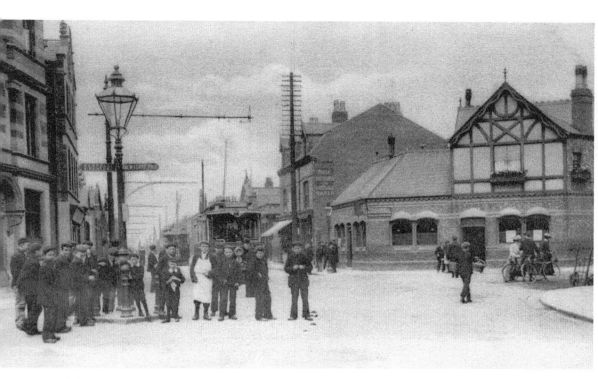

Until the nineteenth century the Wirral was largely rural and undeveloped and the area of New Ferry consisted of a tidal inlet of the River Dibbin to the south and areas of flat marshes. A ferry probably ran from the shore during the Middle Ages onwards. The gradual growth of Lower Bebington at the junction of turnpike routes from Neston on the Dee Estuary and Chester, and the combined road northwards through Tranmere and on to Birkenhead brought more trade to both New Ferry and Rock Ferry. A daily coach bound for Chester departed from New Ferry during the mid-1770s. The New Chester Road turnpike – today's A41 – was rerouted in the 1830s through Bromborough Pool and bypassed Bebington village, and undoubtedly brought more trade to the ferry. The photograph shows the Toll Bar Corner, Toll Bar Junction on the New Chester Road, Bebington Road and New Ferry Road. It was here that tolls were collected on the new turnpike (the present B5136). The tram was operated by Birkenhead Corporation Tramways between 1901 and 1937 on the reconstructed horse-drawn Wirral Tramways New Ferry Line.

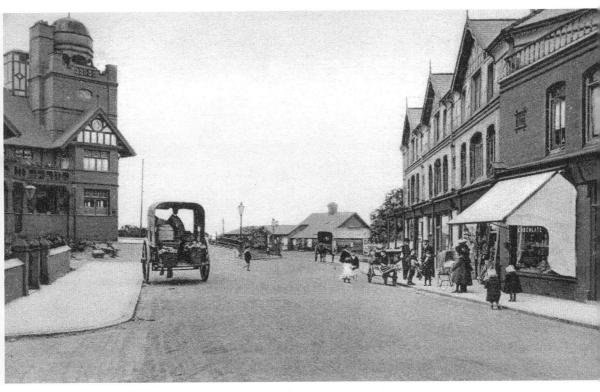

By the second decade of the nineteenth century the Eastham and Birkenhead ferries had changed over to steam power from sail, and crossings to Liverpool became speedier, more frequent, less hazardous and possibly even comfortable! With the improved ferry service and land cheaper than in Liverpool, the Wirral shoreline became an attractive alternative to the congested and polluted city for the wealthy classes – principally merchants and businessmen – and many set up their residences in the Bebington and New Ferry districts avoiding the rapidly expanding population centre of Birkenhead. With them came their servants and shopkeepers, tradesmen and workers. The approach road between New Ferry Pier and the Toll Bar Corner soon attracted many newcomers from all classes, and New Ferry soon developed as a commercial centre remote from Bebington. The hotel at the Esplanade and the row of shops on the right were all replaced in the 1990s by modern housing.

Opposite: A view of the Esplanade and the rooftop of the Rock Ferry Hotel protruding above the trees next to the ferry terminal. The slipway on the right leads up to the Dell. With the exception of the sea walls, the beach and the Mersey, everything else has gone. However, the view from the Esplanade, the Dell and Rock Park Road are as impressive as ever and encompasses a large stretch of the Liverpool shoreline and waterfront. The ferry service gradually became uncompetitive when the Mersey Railway (MR) opened the tunnel link from Liverpool in 1886. By 1891 there were improved connections between the GWR & L&NW Joint Chester & Birkenhead line station at Green Lane, while the MR further improved cross-river services to Liverpool. Birkenhead Corporation took over the running of the ferry in 1897 and operated it at a loss. The service finally closed in 1922 when a ship collided with and damaged a large part of the pier.

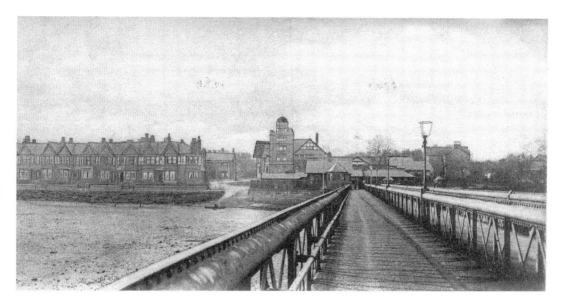

New Ferry Pier and ferry terminal was built in 1865 as a private venture by a Liverpool businessman named MacFie, replacing whatever unofficial and makeshift ferries operated from the shoreline. The new South End Ferry Company operated two steam ferryboats between New Ferry and Harrington Dock and Dingle, Liverpool. The ferry operated successfully for a number of years and served as a useful route to Liverpool for residents of Bebington, New Ferry and Port Sunlight. The ferry also became a popular summer destination for day-trippers from Liverpool who came to visit such delights as the Shorefields Park, the Mersey riverside and beach with donkey rides on the shore, the bowling green and tennis court at the Great Eastern public house, the New Ferry Hotel and shops at the Esplanade. The terraced row of houses is still recognisable from the waterfront although the ferry terminal, hotel and iron pier have disappeared.

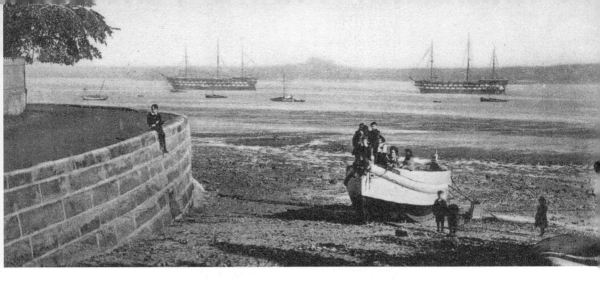

The New Ferry shore at the Dell. A group of children can be seen on the boat, which belonged to one of the training ships moored in the Mersey Estuary. The boat would have been used to carry provisions, supplies, boys and training officers to the ships. Four training ships were moored in the Mersey Estuary, they were: the frigate HMS *Conway*, founded in 1859 for the training of officers for the Merchant Navy; two Christian denominational reformatory ships *Akbar* and *Clarence*; and the frigate *Indefatigable*, which was used by the Liverpool Sea Training School for Boys. The school was founded in 1864 by John Clint, a Liverpool ship-owner, and it aimed to train sons of sailors as well as destitute and orphaned boys, to become merchant mariners. The school was also supported financially by the Bibby shipping family.

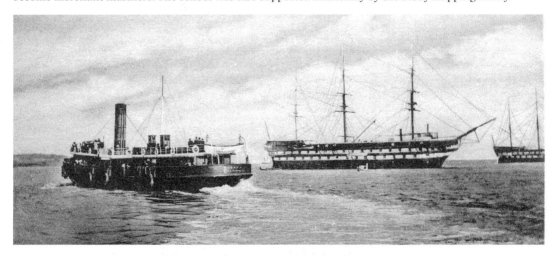

Here we see the Birkenhead Corporation steam ferry *Mersey* bound for Liverpool and the training ship HMS *Conway* (but not the original coastguard frigate offered to the school by the Admiralty in 1859). HMS *Winchester* replaced the original *Conway* in 1861 and she was replaced by HMS *Nile*. In 1876 both vessels were renamed *Conway*. The last TS *Conway* was moved from the Mersey during the Second World War to a safe mooring at the Menai Strait. In 1953, an attempt was made to return the *Conway* to the Mersey but she ran aground and was badly damaged. After proving to be unsalvageable, she was broken up in the Menai Strait. The steam ferry *Mersey* was involved in the rescue of officers and boys from the reformatory ship *Clarence* which was destroyed by a fire in 1899.

Kings Lane, Rock Ferry, in the early 1900s. Here we see how rural the surrounding countryside around Rock Ferry, New Ferry and Bebington looked before the expansion of housing. The lane is now flanked with inter-war housing, although it remains tree-lined for most of its length. Radiating from the lane that extends as far as Kings Road is a series of boulevards with the names Woodburn, Princes, Berwyn, Garth and Cornville, and avenues named Queenswood, Bickerton and Withert. These were all part of the district's newly developed housing.

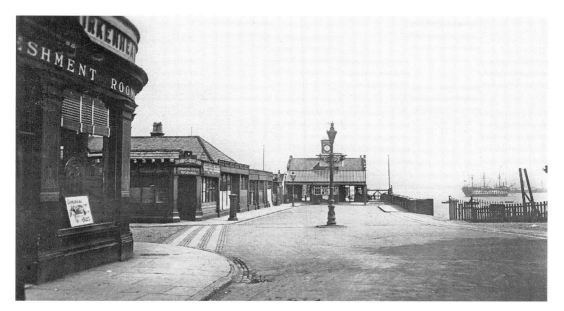

Rock Ferry Pier with, in the distance, TS *Conway*. The ferry possibly dates back to the early eighteenth century and the crossing was operational up to 1939. It outlived New Ferry by eighteen years, but ultimately proved uneconomical and services where eventually discontinued. The terminal and its clock tower are at the end of Bedford Road, while immediately to the left is the Refreshment Room of the now closed and boarded-up Admiral Pub. The cobbled stone roadway has survived in places and the lower walls of the Thomas Hobson Riverside Works are still in situ. Nearby are the premises of the Royal Mersey Yacht Club, founded in 1844 at Liverpool, and moved to its present location in Bedford Road East in 1901.

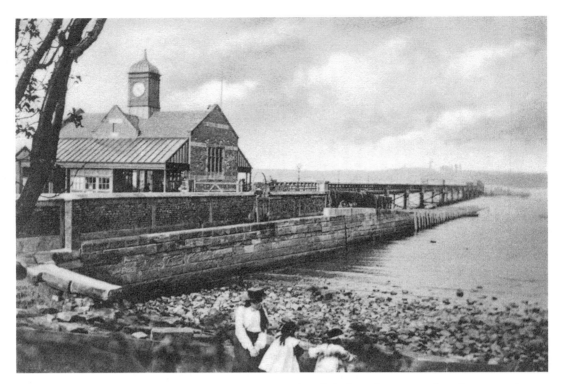

The terminal building at Rock Ferry seen here was demolished in the 1950s, but the stone slipway remains, as does the pier, which is used as a jetty by Tranmere Oil Terminal.

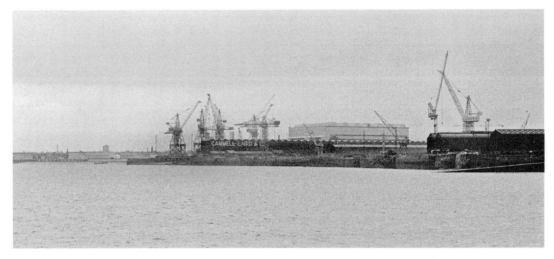

Cammell Laird & Co. seen from the Mersey in its last decade before closure and receivership in April 2001. Founded by William Laird at Birkenhead in 1828, Laird, Son & Co. merged with Sheffield-based Johnson Cammell & Co. in 1903 to create one of the most famous shipyards in the world. Throughout the company's history, the Cammell Laird yards built and launched over a thousand ships from its Mersey frontage. The yards consist of wet docks, graving docks, launching slipways, engine erecting shops, machine shops and a covered assembly hall.

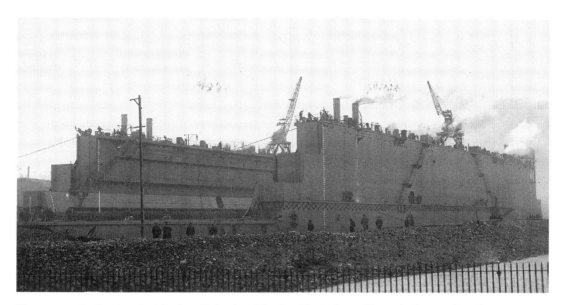

Here we see the floating dock built at Birkenhead for the Admiralty and launched on Wednesday 14 August 1912 from Cammell Laird. At the time, it was the largest floating dock in the world at 640ft long and weighing over 30,000 tons. It was constructed in a basin 700ft in length and 145ft wide.

A glimpse of the Cammell Laird shipyard from the deck of Mersey Ferry *Woodchurch* on a dull and drizzly day. The last vessel to be constructed at the yards was the nuclear submarine HMS *Unicorn* – her keel was laid down in 1990 and she was launched in April 1992.

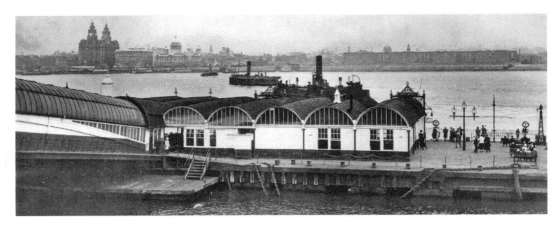

The monks of the nearby Benedictine Priory founded in 1150 probably ran the earliest Birkenhead ferry, and the earliest written references to a ferry between Birkenhead and Liverpool date to the early fourteenth century. The 1318 charter granted by Edward II gave the priory the power to charge for hospitality to passengers crossing the Mersey. In 1330 another charter granted by Edward III gave the priory legal right of ferry. The photograph here shows the floating landing stage at Woodside during the mid-twentieth century. The ferry was established here in the 1820s and a slipway and subsequently a stone pier led to the river. The floating landing stage was constructed in the 1860s and connected to the booking hall on the edge of the river by a hinged, covered walkway which could rise and fall with the landing stage. The whole terminal was completely rebuilt in stages by the end of the 1980s.

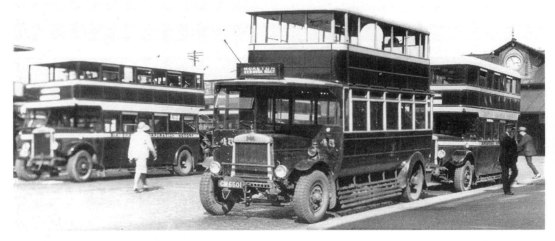

The bus rank at the front of the ferry terminal building has been an enduring feature here for over 140 years, and today a modern bus terminal carries on the tradition. In August 1860, horse bus operators protested about the opening of an American-style horse-drawn street tramway between Birkenhead Park and Woodside Ferry. Introduced by George Francis Train, at the time the street tram was a new concept in the British Isles. Birkenhead Corporation Tramways took over the operation of the existing horse tramway system and introduced electric traction to Woodside Ferry and for a time the tram took over precedence from the horse-drawn bus. From 1919, Birkenhead Corporation started to run motor buses and in 1937 the tram service was completely withdrawn leaving just the bus rank at Woodside. However, the electric tram has made a come back to Woodside with the opening of the Birkenhead Wirral Tramway in 1995, and today both trams and buses share the forecourt of the ferry terminus.

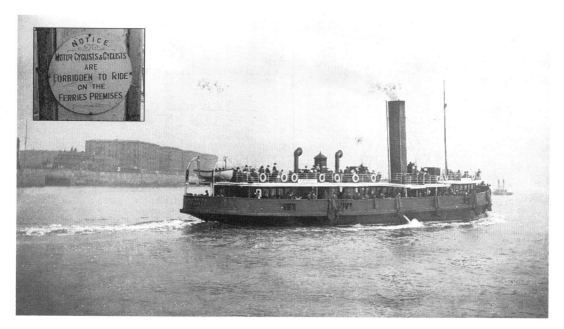

The right of ferry from Birkenhead to Liverpool was granted by Edward III in 1330. With the dissolution of the priory, the rights of passage passed to the Crown. The estate and manorial privileges, which included the ferry, were purchased by Ralph Worsley and subsequently transferred to his descendants. From the mid-nineteenth century, the Commissioners of Birkenhead and Mersey Docks and Harbour Board arranged to operate the ferry, and in 1877, legal responsibility passed to the Borough of Birkenhead. The photograph shows the steam ferry *Lancashire* in the first decade of the twentieth century, which with other steam vessels operated the passenger service from the floating stage. A floating roadway serving the terminal was opened in 1868 and *Lancashire's* sister *Storeton*, the twin-screw steamers *Mersey* and *Wirral* and the double-ended four-screw flush deck steamers *Oxton* and *Prenton* equipped to carry vehicles and goods, had all in turn superseded the older paddle-steamers at Woodside.

Woodchurch approaching the floating landing stage at Birkenhead. The 800ft long and 80ft wide landing stage connected to the terminal building with a circular glass-covered pedestrian bridge. From 1868, goods traffic and vehicles were conveyed along a 670ft long and 30ft wide floating roadway.

Two views of MV *Woodchurch* tying up at the old floating landing stage in the final years before it was replaced during the 1980s after 120 years' service.

In 1984 part of the terminal was demolished and during the following year, the terminal building was rebuilt. The floating landing stage was partially demolished and sections were removed, the remaining structure then being replaced with a new floating stage. The new terminal was officially opened in 1986.

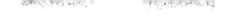

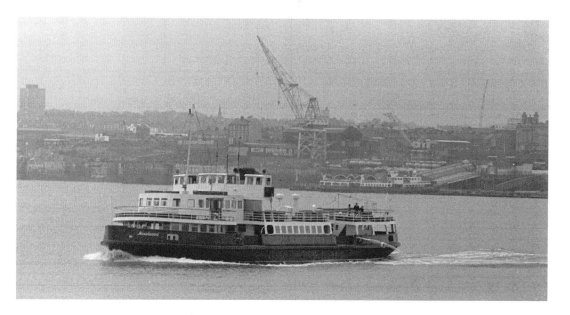

MV *Mountwood* making her crossing of the Mersey bound for the Pier Head at Liverpool. At the riverside is the Birkenhead Woodside terminal and MV *Woodchurch* moored at the floating stage, and behind a once-familiar Birkenhead skyline greatly changed nowadays, although some buildings are still recognisable. The three-storey building at the centre of the picture is the Swinging Arm pub in Church Street, while the building on the far right is the Wirral Magistrates' Courts at the corner of Chester Street and Mortimer Street.

MV *Mountwood*, built in the 1960s, is part of the present fleet of ferries operated by Mersey Travel and Mersey Ferries and along with her sister ships she has been extensively refurbished and refitted. During her refit she was renamed *Royal Iris*, *Woodchurch* was renamed *Snowdrop* and *Overchurch* became *Royal Daffodil*. The fleet works the ferry crossings, charter cruises and the MSC cruise.

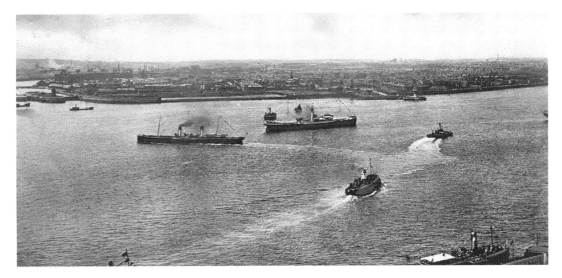

Cheshire and the Wirral peninsula from the Liver Building. To the left of the estuary is the entrance to Birkenhead Dock and the Great Float with its tall flourmills. The two ferries to the right are making their way to Egremont Terminus.

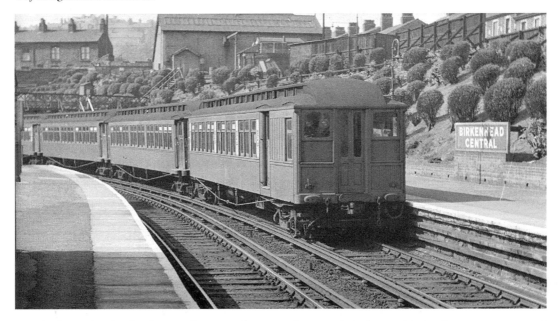

The platform of Birkenhead Central station after electrification of the line in 1903. The station is situated in a deep cutting. Originally the Mersey Railway connected the stations at Liverpool Lime Street and Moorfields to James Street by a loop. The opposite side of the loop ran from Lime Street to Central station and the loop was closed by connecting to James Street station at Paradise Street junction. The combined line then passed through a tunnel under the Mersey. The first station on the Wirral side of the Mersey was Hamilton Square; the MR then split north to join the Wirral line at Birkenhead Park, while a branch extended southwards to Birkenhead Central and Green Lane. This southern branch was connected in 1891 to the GWR & LNW Joint Chester & Birkenhead line and the first station stop was at Rock Ferry.

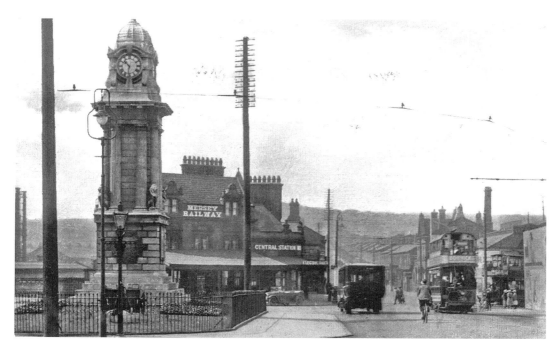

On this page we see two views of Birkenhead Central station. The former offices of the MR are at the corner of Argyle Street and Borough Road. The station looks the same but the whole area has changed dramatically; the A552 flyover bisects the view, and the clock column has been relocated onto a patch of ground facing Clifton Crescent and the Central Hotel.

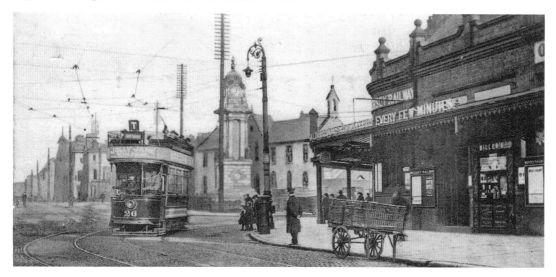

From the opposite direction we see the MR Birkenhead Central station with Birkenhead Corporation tram no. 26, a Milnes open-top double-decker, making its way into Argyle Street from the centre of Birkenhead. This route closed in 1934. The station was the location of the MR headquarters and in the early twentieth century the company was at pains to say how their new clean and efficient electrified services departed for Liverpool 'every few minutes'.

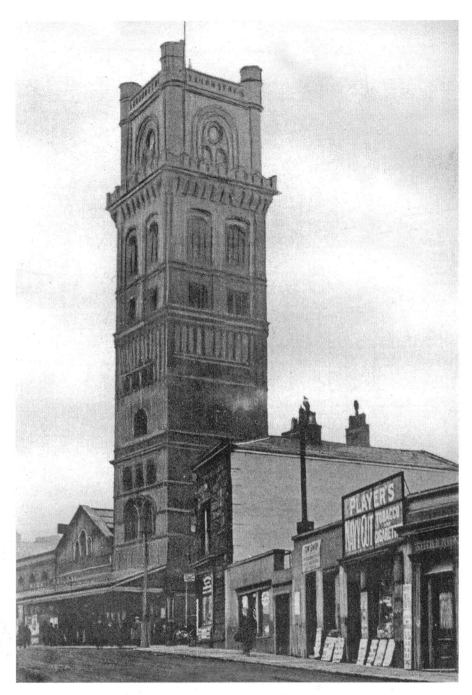

Hamilton Square station on the MR opened to the public on 1 February 1886. The MR's underground route from Liverpool was via the tunnel under the River Mersey – when the line first opened it was steam powered which led to it being unpopular because of the foul and stuffy conditions in the tunnels. The MR's electrified services began on 3 May 1903 and was the first steam underground service to be converted to electric traction in the UK.

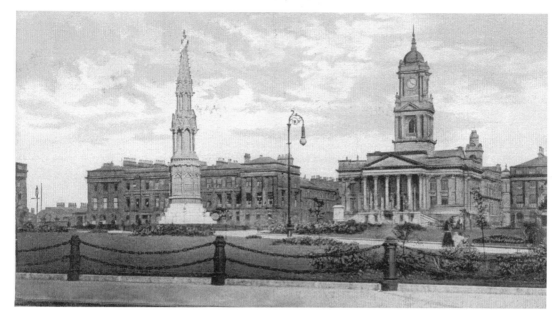

Edinburgh architect James Gillespie Graham designed the impressive Georgian terraced houses overlooking Hamilton Square in Birkenhead. William Laird owned the land and building began in 1826 and continued for twenty years to completion. The square was named after Laird's wife's family name. Designed by Charles Ellison, Birkenhead Town Hall opened in 1887 and is built of Scottish granite and Storeton sandstone. In front of the hall is the cenotaph. The gardens at the centre of the square have a monument dedicated to Queen Victoria and there is a statue of John Laird, MP for Birkenhead.

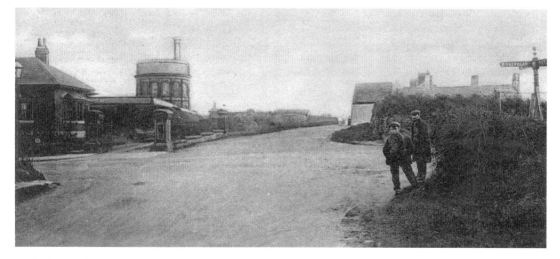

With the rapid growth of Birkenhead in 1833, an appointed group of improvement commissioners were tasked with maintaining the infrastructure of the growing town and its suburbs. They also met the challenge for improvements to transport, docks water supply and sewage. The Birkenhead Improvement Commissioners made a number of purchases and investments to improve services. One was the Flaybrick Waterworks. Flaybrick and Flaybrick Hill is also known as the site of the municipal cemetery designed by Edward Kemp, curator of Birkenhead Park, and it officially opened on 30 May 1864.

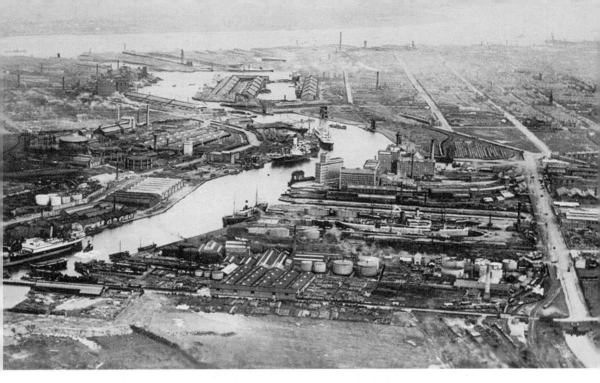

Unlike Liverpool Docks which follow the coastline of the Mersey Estuary, the Birkenhead Dock estate extends approximately 2 miles inland along the Great Float, formed from a natural tidal inlet of Wallasey Pool. The Great Float divides into two large docks, the East Float and West Float now isolated from the River Mersey by a set of tidal locks, and this pool of water naturally divides Birkenhead from Wallasey. The Great Float was reclaimed from Wallasey Pool between 1851 and 1860. Designed by James Meadows Rendel and managed by the Birkenhead Dock Company, the MD&HB took over ownership in 1858. The Great Low Water Basin, Morpeth Dock and Egerton Dock were the first built and in 1877 Wallasey Dock. Access from the river was via Alfred Dock and Morpeth Dock.

Opposite: The Hydraulic Tower at the entrance to the East Float designed by Jesse Hartley (1780–1860) and completed in 1863. The tower and engine house provided power for moving the lock gates and bridges in the docks. Hartley's design was based on the Palazzo Vecchio (the town hall) in the Piazza della Signoria, Florence. Hartley was the chief designer of many of Liverpool's dockland buildings including the Albert Dock and its warehouses. His tower was damaged during bombing in the Second World War and was hastily repaired. Today neglected and vandalised, it has survived to stand in isolation on the deserted Tower Road.

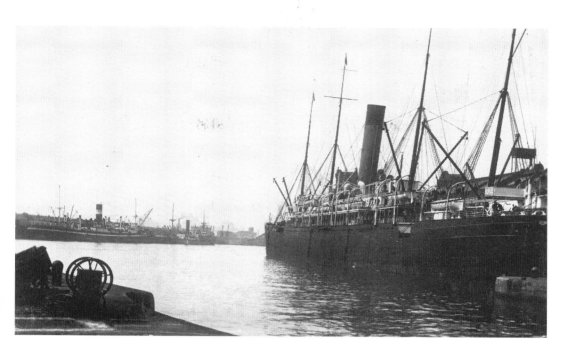

The docks enclose over 150 acres of water and extend from the tidal lock gates at Seacombe into the East Float through Alfred Dock and under the first lift bridge at Tower Road. In turn, the East Float connects to the West Float under the Duke Street bascule bridge to reach Bidston Dock (now filled in) and Wallasey Bridge Road. Located on the wharves in the East Float were the main warehouses and flourmills. Much of this once-impressive dock estate has fallen into terminal decline and many of the warehouses have been demolished, but the port continues to survive. In 2002 the 'roll on – roll off' Twelve Quays Container Terminal was opened to revitalise Birkenhead's growth in the Irish Sea trade.

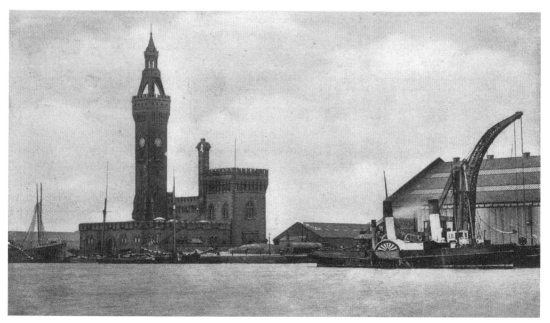

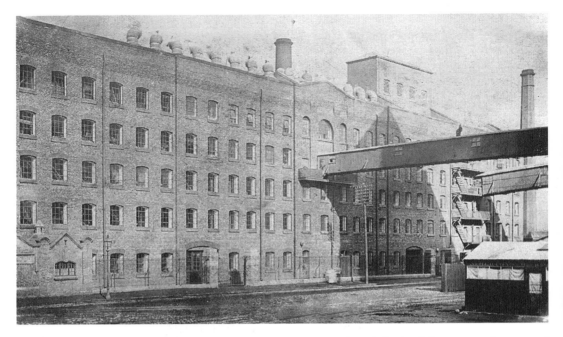

The Corn Laws and Importation Act of 1815 protected the profits of the landed gentry and prevented open competition and the import of cheaper grain, especially through the ports. The repeal of these trade restrictions by the Importation Act of 1846 allowed foreign imports of grain through British ports, among them Liverpool, Birkenhead and Manchester. By the end of the nineteenth century, Birkenhead had built many warehouses to store imported grain before transshipment to the developing industrial cities of Lancashire. By the early twentieth century, the East Float quaysides had become an important flour-milling centre. Companies such as Joseph Rank Ltd and Spillers occupied much of the dock estate in the late twentieth century, but many of the mills have now been demolished after a long and protracted decline in the industry. Two warehouses have survived which have been converted into apartments.

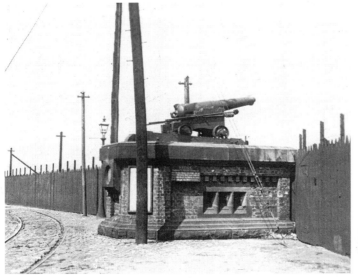

The one o'clock gun, a relic from the Crimean War, was fired to give a time signal to shipping on the Mersey. From 1867, it was fired remotely from Bidston Observatory. The old gun and plinth can still be seen, although the tradition of firing ended at 1.00 p.m. on 18 July 1969, despite the fact that the gun was no longer required for synchronising GMT, and radio signals had long superseded the need for it.

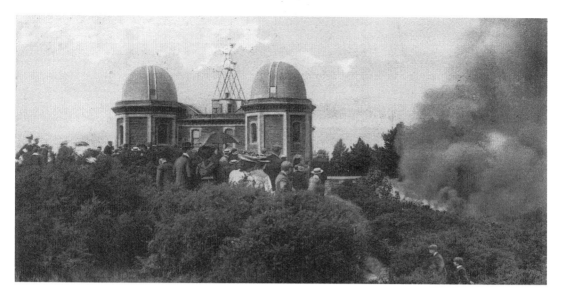

Bidston Observatory, built in 1866 on behalf of the MD&HB, stands on the highest hillside on the Wirral. It is surrounded by 100 acres of heathland and woodland purchased by Birkenhead Corporation in 1894. Fires on the heathland were commonplace and dry summers often led to such occurrences. Bidston Observatory had a number of maritime roles, essentially aiding navigation. One role was the exact determination of Greenwich Mean Time by astronomical observations made from the two domes which housed telescopes and optical instruments. The exact time was communicated to shipping at Birkenhead and in the Mersey Estuary by releasing a time ball on the roof of the observatory. The building is now disused and research has transferred to the Proudman Oceanographic Laboratory.

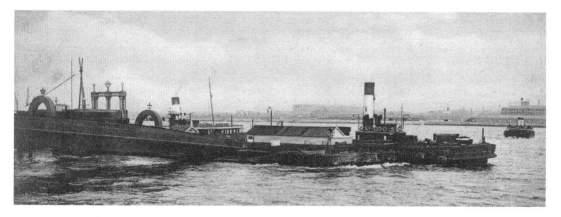

A rudimentary ferry probably operated from Seacombe from the early sixteenth century, and even up to the early eighteenth century passengers often had to wade to and from their boat at low tide. Gangplanks improved on the situation, but in 1835, a stone slipway was built with a running-out stage mounted on rails, which was allowed to run out by its own weight and could be winched back with the rising tide. The last private owners, the Coulborn Brothers, sold their interest in the ferry to Wallasey Local Board, which by 1876 had rebuilt the terminal; a floating stage was added in 1880. The floating stage could accommodate two steam ferryboats. A hydraulic ramp was also provided to raise vehicles from the floating stage at low water to the road. A new and larger stage, 480ft long by 80ft wide, replaced the original in 1925, and by 1931 Wallasey Ferries were carrying on average 27 million passengers a year.

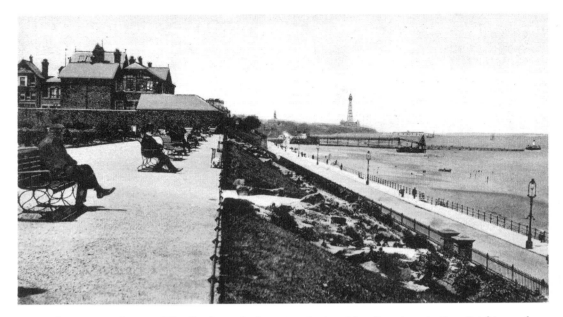

Seacombe Promenade runs 3½ miles from the ferry terminal and landing stage to New Brighton, where the sea air, fresh breeze, spectacular views of the Liverpool coast and the attractions of the Wallasey shore has made for a popular stroll for Wirralians and Liverpudlians for the past 100 years.

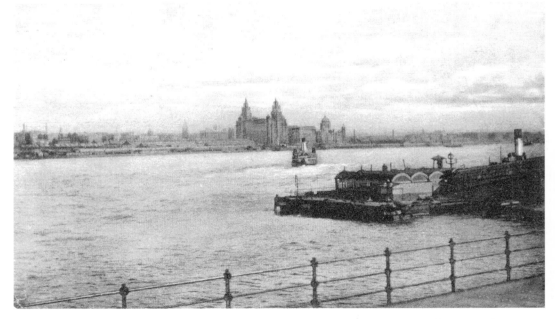

The River Mersey has significantly contributed to the growth of Wallasey and the borough owes its existence to the departing steam ferry from Seacombe. The combined ferries of Seacombe, Egremont and New Brighton – along with the railways – offered cheap transportation for thousands of passengers living on the Wirral and working in Liverpool. The reciprocal weekend and holiday exodus by ferry and train from Liverpool to the pleasant Wirral countryside offered an escape from the grime and congestion of the city.

4

LIVERPOOL & MERSEYSIDE

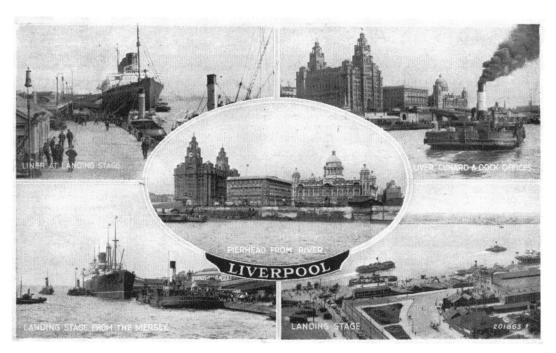

A multi-view photographic postcard of scenes from the Mersey and Liverpool showing the landing stage and the port in its heyday. In the first decade of the eighteenth century, ships anchored in the tidal inlet called the 'pool' or in the Mersey and cargoes where rowed ashore. By the end of the nineteenth century, Liverpool had become the second largest UK port after London, and one of the largest ports in the world. *(Publisher unidentified)*

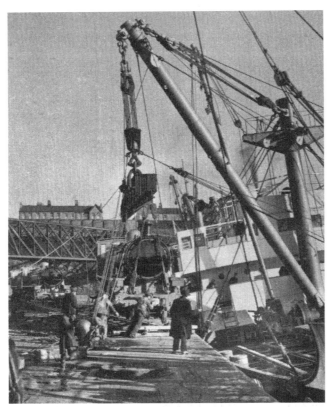

Throughout the eighteenth century, Liverpool was little more than a coastal port, but by the start of the nineteenth century the growth of the tobacco trade from Virginia, sugar from the West Indies and the slave trade had changed its fortunes. The Mersey and Liverpool had become the so-called 'Western Gateway' for the import of huge quantities of raw materials and the export of manufactured goods from the industrial towns and cities of the Midlands and north of England. The range of manufactured goods seemed unending, from the smallest household items to knives and forks, as well as clothing and textiles to the shipping of locomotives and heavy machinery.

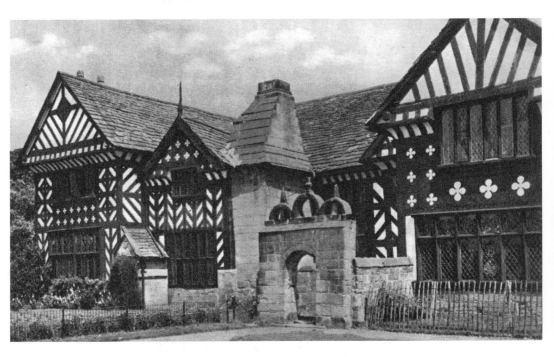

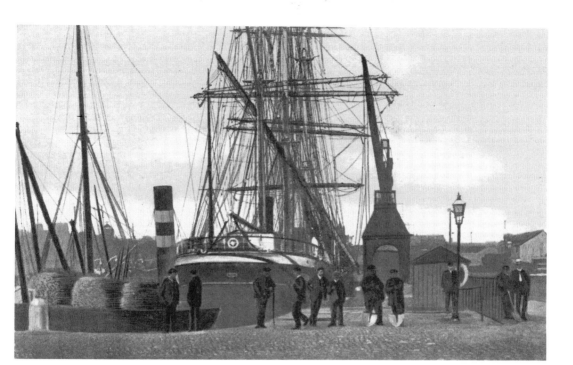

Comprising three separate basins – Old Dock, North Dock and Stalbridge Dock – the then Garston Dock (also known as the Port of Garston) was built by the St Helens & Runcorn Gap Railway Co., and opened in 1853. The docks are now a container port operated by Associated British Ports. Garston has remained successful because of the introduction of new containerised cargo-handling methods, while the conventional port facilities at Liverpool rapidly became obsolete.

Opposite: The Garston Channel on the tidal Mersey runs from Garston Rocks beside the entrance to Garston Dock to Dingle and Pier Head further down the estuary. Speke Hall and Liverpool John Lennon Airport are on its north shore. The Tudor manor house of Speke Hall once belonged to the Norris and Beauclerk families until it was purchased at the end of the eighteenth century by the Watts. The last Watts heir, Miss Adelaide, had no descendants and the house was kept in trust before eventually passing to National Trust in the 1940s.

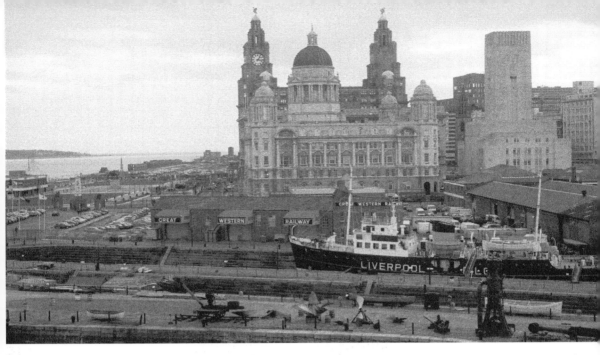

The Dock Offices, Liver Building and floating stage from the Albert Dock warehouses north-east stack, looking down onto Canning Island and the Canning Half-Tide Dock and graving docks. The scene below is from the early years of the nineteenth century and above we see how the dock appeared after its official reopening in 1988 by HRH Prince Charles. Albert Dock was designed by Jesse Hartley and was opened in July 1839 by the Prince Consort HRH Prince Albert; at the time not all of the five blocks of warehouses were completed.

At the time of its completion in the second half of the nineteenth century, Albert Dock was a significant advance. Built to a fireproof design using brick, stone and cast iron-framed construction, multi-storey warehouses enclosed the dock basin and goods were loaded and unloaded directly from ships, a system that

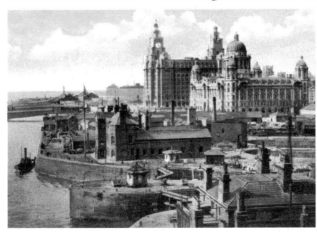

improved security and allowed the docks to be used for bonded goods such as tea, tobacco and wine. The final innovation of the dock was the addition of the Hydraulic Tower in 1878, to power cranes and hoists. Today it is the pump house pub. The limited 45ft wide dock entrance restricted the entrance to larger modern ships, which eventually led to the decline of the whole dock complex. In 1971, the docks finally closed as the tidal locks fell into disrepair and the dock basins were drained of water for a decade. Through the efforts of the Merseyside Development Corporation, the gradual and systematic reclamation of the historic site was begun. Milestone events such as hosting the 1984 Cutty Sark Tall Ships Race, the occupation of former warehouses by the Maritime Museum, the opening of the Tate Gallery and the Beatles Story greatly stimulated the process of refurbishment and renovation to the extent that the docks are now one of Liverpool's most popular visitor attractions.

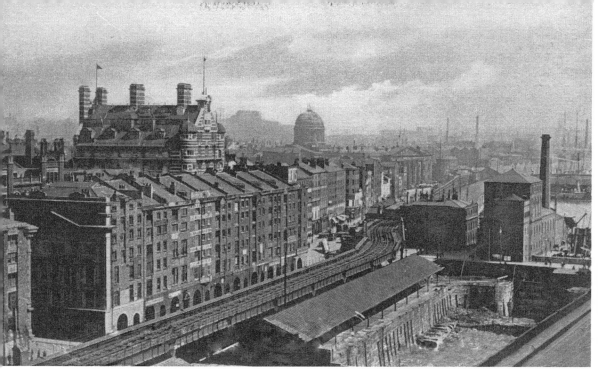

The oldest commercial wet dock in the world designed by Thomas Steers (1672–1750) and built in Liverpool in 1715, within a few years brought about the extensive development of the Mersey waterfront into an extensive dockland and port. The bird's-eye view to the south of Liverpool shows the docks and the Liverpool Overhead Railway (LOR) above Strand Street, while immediately below is the former entrance to the infilled George Dock, later the site of the Queensway Tunnel ventilation tower. The warehouses on the left have been demolished, but the White Star Building (Albion House) at the corner of James Street and the Strand rising over the roofline, remains intact. Thomas Henry Ismay (1837–99) founder of the Oceanic Steam Navigation Company before it took the name and flag of the White Star Line, commissioned this early example of an office block built in 1894; the design was by Richard Norman Shaw (1831–1912) and J. Francis Doyle (1840–1913). The dome of the Custom House building housing the MD&HB offices can be seen in the distance. It was built between 1828 and 1839 to a design by John Foster Snr (1758–1827), Liverpool Corporation's Surveyor and Architect. The building was badly damaged during the Liverpool Blitz and never repaired. The site was cleared some years later.

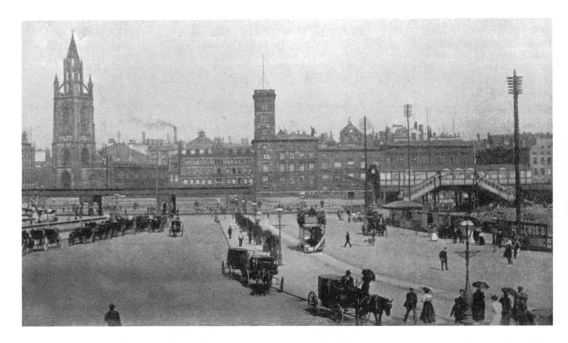

At the turn of the nineteenth century and the early years of the twentieth century, Liverpool and the Mersey held an enviable reputation as one of the greatest ports in the world, famous for trading links to the Americas, Africa, India, the Far East and Australia. The Liverpool Overhead Railway (LOR) conveyed thousands to the Mersey Pier Head, including mariners, dockers, steam ship passengers and cross-river commuters. The trams did likewise, and for the wealthier there were horse-drawn taxi-cabs. At the heart of the port, the Pier Head had become the central gateway to the Wirral Peninsula, Dublin and the Isle of Man as well as to most of the greatest ports of the world.

Surrounded by five-storey warehouses, Fred Talbot's floating weather map was the star attraction of Granada Television's *This Morning* TV show. Crowds would gather to watch Fred's daring leaps between the British Isles. Albert Dock and the former Dock Traffic Office was home to Granada Television Studio's Liverpool operation from 1986 to 2000. While the docks were still operational, ships berthed at the quaysides were unloaded by hydraulic hoists, lifting goods directly into the warehouses. Goods could latterly be transferred to the dock railway and road. A series of 4ft wide colonnades support the warehouse block and at even intervals they are separated by arches, which were used to extend cranes from.

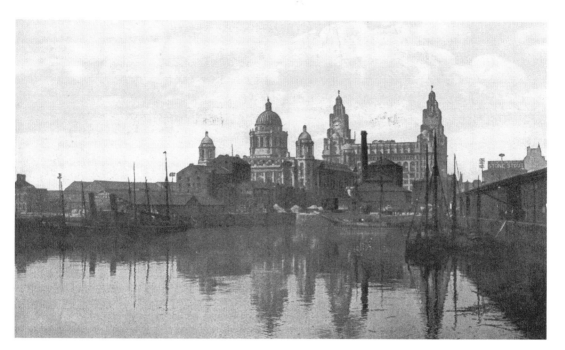

In 1715, Thomas Steers managed to enclose part of the original 'pool' to build Liverpool's first wet dock – the 'Old Dock'. The dock traded goods but also slaves and was filled in 1826, and the reclaimed land was used to build the Customs House. Canning Dock, named after Liverpool MP George Canning (1770–1827), was built from the entrance of the 'Old Dock' in 1737 and connected to Canning Half-Tide Dock by a set of lock gates. The entrance to the graving docks on Canning Island, built in 1765, can be seen on the left, and today Mann Island Lock takes the extension of the Leeds & Liverpool Canal into Canning Basin.

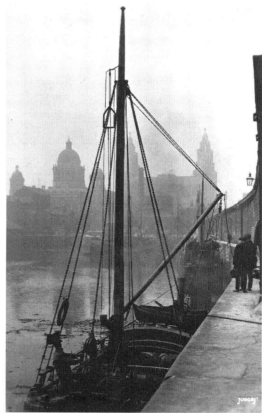

Another view of Canning Dock and the dock wall separating it from Strand Street and the elevated LOR. The dock was overlooked for its entire length by a stretch of the railway which ran between Custom House station and James Street station. By the mid-1940s the dock had ceased to be of use primarily owing to the limited size of the of the dock entrance which restricted access to larger vessels. Towards the end of its useful life it served as a harbour for coastal traders and fishing vessels. The graving docks belong to the Maritime Museum and sail-training ships and pleasure craft use the basin.

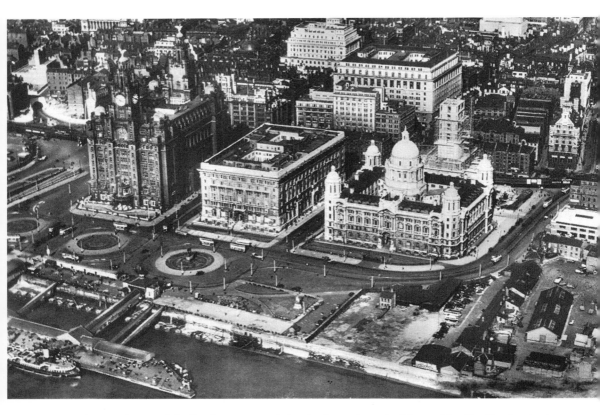

An aerial view of the landing stage and the city from above the Mersey. The Pier Head today is greatly changed and is no longer a large plaza occupied by buses, trams and vehicles queueing to drive onto ferries. Although the buses and ferries are still close by, the large space in front of the Liver, Cunard and Dock Offices is taken up by the newly constructed extension of the Leeds & Liverpool Canal and the newly constructed Museum of Liverpool.

Opposite: The Port of Liverpool Building, formerly MD&HB offices – otherwise known as the Dock Office, was designed by Sir Arnold Thornley (1870–1953) and F.B. Hobbs. Built in 1907, it was constructed of reinforced concrete and clad in Portland Stone. The MD&HB vacated the building in 1994 and it underwent extensive refurbishment and conversion into rented office accommodation in 2009.

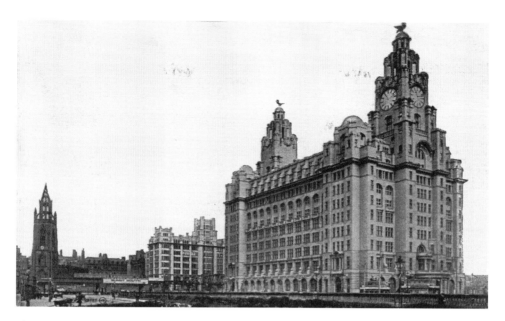

The Royal Liver Building, designed by Walter Aubrey Thomas (1859–1934), is the most readily identifiable building on the Pier Head. Opened in 1911, the building was from the outset the offices of the Royal Liver Assurance Group. The company had been founded in Liverpool in 1850. The two liver birds which stand over 300ft high on the two separate clock towers watch over the city and the Mersey. The mythical birds – supposedly cormorants – designed by Carl Bernard Bartels (1866–1955) are part of the folklore of Liverpool and some traditions say that if they fly away the city will cease to exist. Other popular myths suggest that the bird looking over the city takes care over the inhabitants of Liverpool, while the bird facing out to sea offers protection and hope to sailors.

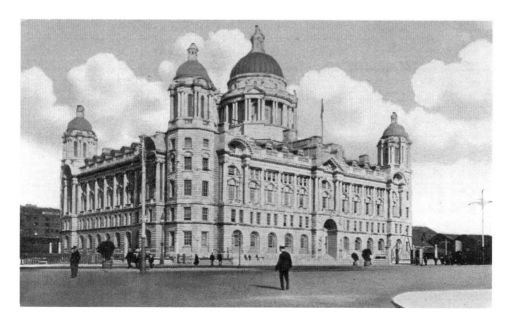

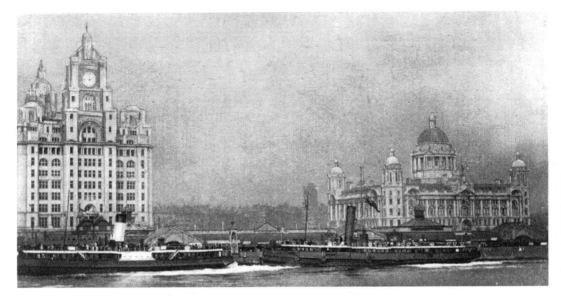

From Cheshire's rival port and conurbation of Birkenhead, the Mersey ferries departed from Tranmere, Woodside (Birkenhead) and Seacombe (Wallasey). To this day, the ferry arrives at Pier Head Terminal in Liverpool and the floating landing stage below the Royal Liver, Cunard and Dock Offices buildings, and beside the newly opened Museum of Liverpool. The picture shows the floating stage from the Mersey with just the Liver Buildings and Dock Offices built.

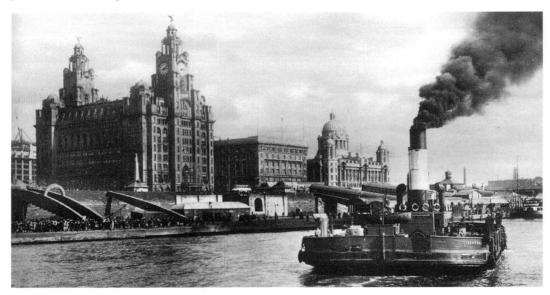

The same view a decade later shows the 'Three Graces'. With the addition of the newly built Cunard Building, together with the Liver and Port of Liverpool Dock Office, these comprise the three iconic buildings of the Liverpool waterfront. Built in the style of an Italian palace, the Cunard Building was constructed of reinforced concrete clad in Portland Stone. The SS *Liverpool* 1906 (later renamed SS *Prenton*) is one of the double-ended four-screw steam-powered luggage boats which ferried vehicles from Wallasey and Birkenhead, and is seen here approaching the floating landing stage.

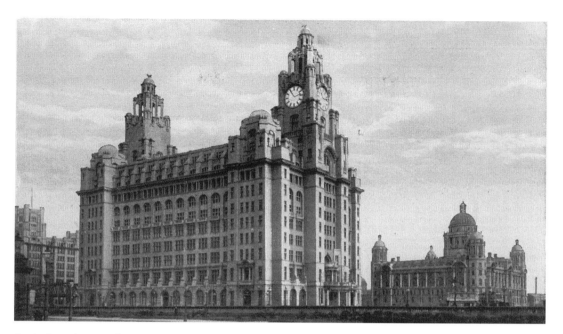

A similar view to the images opposite, this time from the landing stage. showing the Liver Building and Dock Office. The clock faces on the towers of the Liver Building were each 25ft in diameter, and the mechanisms are known as George clocks because they were started at the exact moment of the coronation of George V on 22 June 1911.

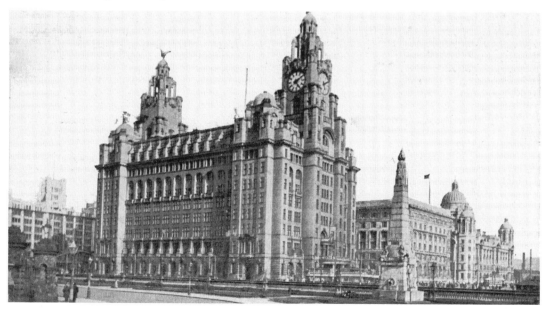

The view from the same spot a decade later shows once again the 'Three Graces' after including the newly built Cunard Building. The granite memorial on the right, designed by Sir William Goscombe John (1860–1952), is located at St Nicholas Place and is dedicated to the Engine Room Heroes of the *Titanic*. RMS *Titanic* belonged to the White Star Line and was registered in Liverpool.

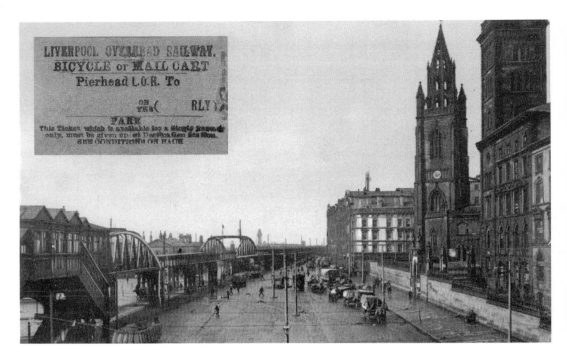

The LOR Pier Head station stood between the Liver Building and the Strand. This view is looking north towards George's Dock Gates and St Nicholas Place, while on the right is Our Lady & St Nicholas. The station opened along with the line in February 1893 and was the busiest stop on the line, within walking distance of the Pier Head tram terminal, ferry terminals and ocean liner landing stage. The railway and station was elevated 16ft above the dock road on iron pillars and gantries, and the MD&HB operated a steam-hauled dockside railway below the elevated sections. Sulphurous fumes from tank engines over many years corroded the ironwork supports and by the mid-1950s, the LOR was in need of major structural work. Strapped for cash and with falling revenue, the line closed entirely on 10 December 1956. The entire line, overhead structures and stations were cut up and demolished shortly after the line closed.

The now sadly missed LOR once ran the length of the port and the dock road from Dingle to Seaforth Sands. From Pier Head station parcel carts and wagons were constantly on the move. Affectionately nicknamed the 'Dockers' Umbrella' because it ran above the dock road and offered protection from the elements to the dock workers below, it also offered a grandstand view of the once-bustling port and docks.

The LOR was an electrified double line and Pier Head station, seen here from Water Street, was an elevated station. Passengers either entered the Up or Down platform from two separate sets of stairways located on opposite sides of the station. The view shows the Down (northbound) side of the station and its two staircases; they met at the entrance to the platform. The two previous views show the opposite stairways that met at the centre of the Up (southbound) platform. The northern extent of the line was at Seaforth & Litherland station on the Lancashire & Yorkshire Railway (L&Y) (with connections to Waterloo & Crosby), while its southernmost extent and terminal was at Dingle Park Road station. The LOR and L&Y for a time offered a popular through race day service to Aintree for the Grand National.

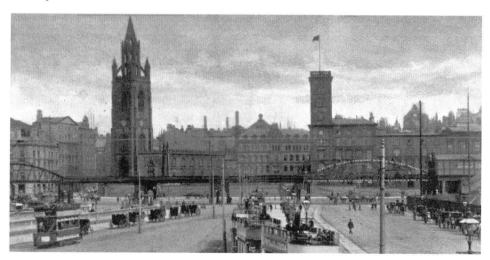

A view of the LOR passing in front of the church of Our Lady & St Nicholas, also known as the Sailors' church and St Nick's. The tower of the old church collapsed on Sunday 11 February 1810. As the bells were pealed, masonry and the heavy bells fell to crush and kill twenty-five members of the congregation. In the following century, the church was destroyed by fire during a German air raid on 21 December 1940. The church was finally rebuilt in 1952.

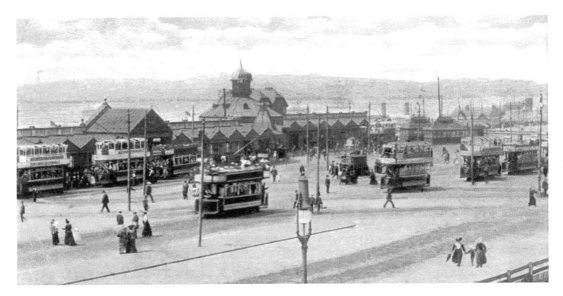

From the late nineteenth to the early twentieth century, Liverpool had become the departure point for thousands of European migrants seeking a new life in the New World. They arrived by train from London and the east coast ports of England to congregate at the Pier Head and Landing Stage before boarding their ships. Originally, the Prince's Landing Stage and the Pier Head served the ocean liner service and the George's Landing Stage, added in 1890, served the Wallasey and Birkenhead ferry services. Lengthened over time, the stage eventually stretched for almost half a mile along the Liverpool waterfront.

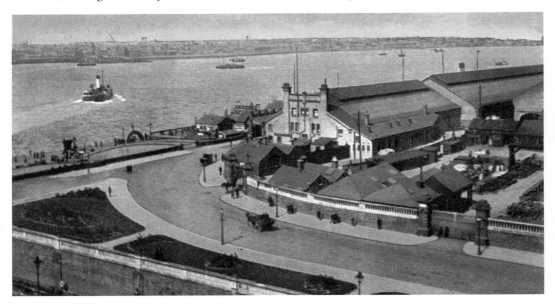

Pier Head and the Floating Landing Stage. On the right is MD&HB Liverpool Riverside station, opened in 1895, which was used as a terminus for boat train traffic via Edge Hill on the L&NW. With the loss of the liners, the station closed in 1971 and the building was subsequently demolished after having lain derelict for a number of years. The landing stage was also demolished in 1973 and the whole site has now been redeveloped with new offices. The Isle of Man Steam Packet service continues to operate from the Prince's Landing Stage.

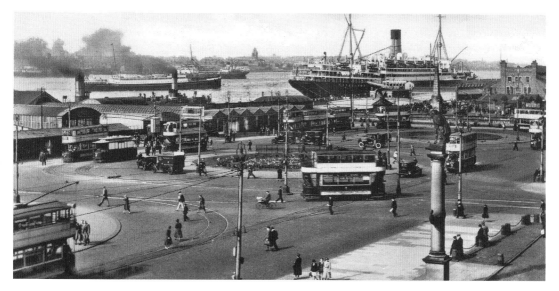

A view of the tram terminus at the Pier Head from the front of the Cunard Building and Canada Boulevard. A Cunard liner is berthed at the Floating Landing Stage and the Cunard Monument can be seen on the right, erected in 1921 as a memorial to all the Cunard employees who died in the First World War. The Liverpool Corporation Tramways network radiated from Pier Head in all directions through the city, the system being almost 100 miles long. The boundaries of the system extended southwards to Garston, northwards to Bootle and eastwards to Clubmoor, West Derby, Knotty Ash, Childwall and Wavertree. The system closed on 14 September 1957 and buses then took over services from Pier Head.

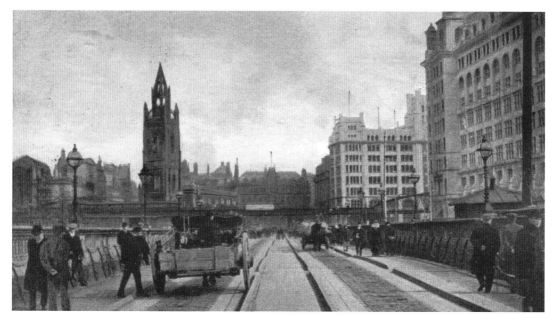

Pivoted and hinged from its head at the junction with St Nicholas Place and at the riverside end with the floating stage, the approach road to the Floating Landing Stage was able to move up or down with the rising and falling tide.

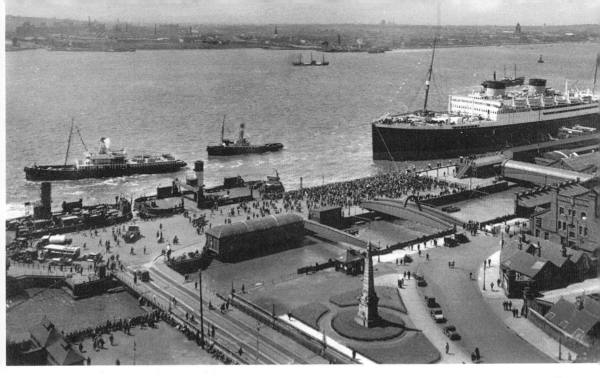

Here we see the luggage boats taking on vehicles and foot passengers awaiting the arrival of the Wallasey and Birkenhead ferry. Crowds have also gathered to view the ocean liner berth at the floating stage. The approach road to the floating stage is in front of the *Titanic* monument and St Nicholas Place.

The Birkenhead ferry making its way across the Mersey. Beyond it is the Birkenhead shore with the Hydraulic Tower clearly visible. Many of the warehouses on the dock estate have been demolished and the Twelve Quays Terminal for passenger and freight services to Ireland now occupies the site.

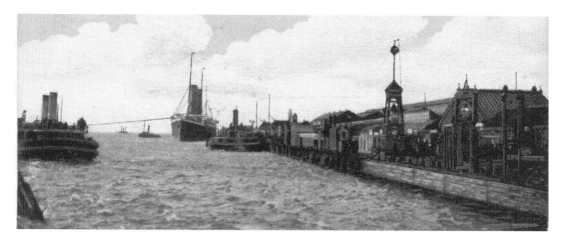

The departure of an Edwardian ocean liner from the landing stage. Tugboats helped turn the vessel to face downriver and into mid-channel. Cunard and the White Star Line, two immensely prestigious rival maritime shipping lines, were for a time associated with Liverpool; both companies operated transatlantic services. Samuel Cunard (1787–1865) founded the British & North American Royal Mail Steam Packet Co. in 1840 for the Liverpool–Halifax–Boston transatlantic route. The company converted to a public company in 1879 and called itself the Cunard Steamship Co., Ltd. Cunard's main competitor, the White Star Line, was a constituent company of a bankrupt Liverpool-based shipping conglomerate. In 1868 the White Star name was purchased by Thomas Henry Ismay (1837–99), who founded the Oceanic Steam Navigation Company to operate a new class of ship built by Harland & Wolff. The White Star name was resurrected in 1871 for the Liverpool and New York Atlantic service.

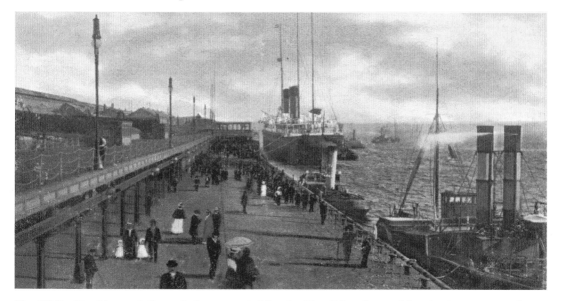

The White Star Line and Cunard also competed for the Blue Riband award for the fastest transatlantic crossing. Both companies held the coveted prize. SS *Teutonic*, seen here at the landing stage, was a White Star ship launched in January 1889. She held the Blue Riband in 1891, taking it from her sister ship *Majestic*. The White Star Line never held the Blue Riband again and directed their efforts to economy and comfort.

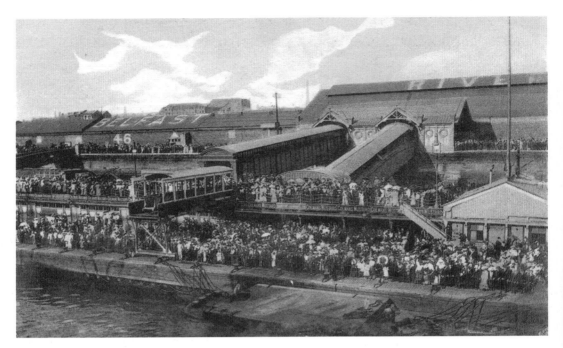

The view from an ocean liner departing from the Mersey landing stage. White Star Line ships departed for New York every week. From the end of the nineteenth century to the mid-twentieth century, among each ship's passenger manifests were thousands of European migrants bound for the immigration offices at Ellis Island. White Star ships called at Cobh in Ireland to pick up more passengers, of whom hundreds were Irish immigrants.

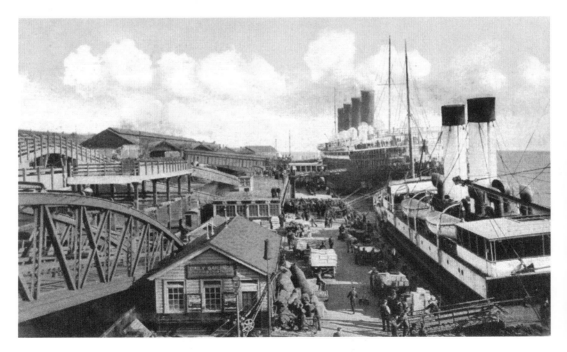

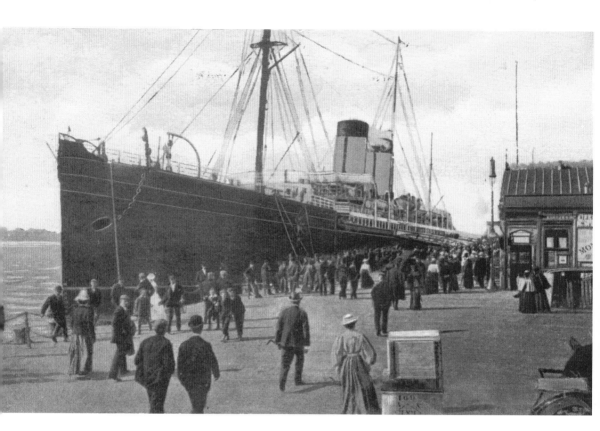

RMS *Umbria* on the Liverpool Mersey landing stage. Built by John Elder & Co. at Glasgow and launched in 1884, the old Cunard ship was the last of a generation of transatlantic steamships fully rigged with sails. The view shows the *Umbria* in the last decade of her life. She was scrapped at Bo'ness on the Firth of Forth after her final Atlantic crossing and returned to the Mersey in 1910.

Opposite: Cunard's RMS *Mauretania* and the Dublin (Ulster & Munster) steam packet. The British Government provided Cunard with a subsidy to build two ocean liners to retain its competitive position and to take the Blue Riband prize that *Mauretania* succeeded in, and held from 1907 to 1929. Swan Hunter & Wigham Richardson at the Tyne and Wear shipyards built *Mauretania*. Her sister ship *Lusitania*, also designed by naval architect Leonard Peskett (1861–1924) and built by John Brown & Co. on the Clyde, sank in 1915 after being torpedoed by a German U-boat. The sinking was one of the reasons for the USA entering the First World War.

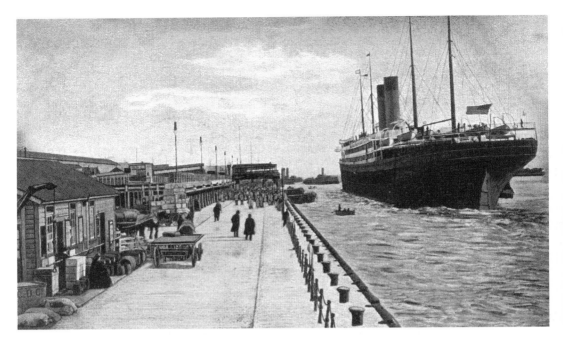

The White Star liner RMS *Cedric* coming into berth at Liverpool landing stage. *Cedric* and her sister ships the *Baltic*, *Adriatic* and *Celtic* comprised the White Star Line's 'Big Four' ocean liners. A new generation of Edwardian super liner, *Cedric* was launched from Harland & Wolff, Belfast, in 1902.

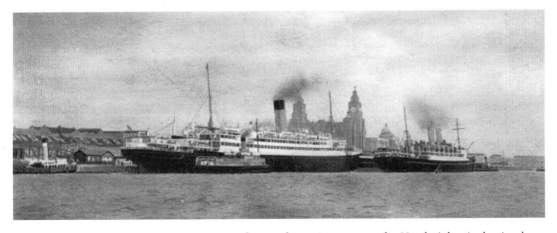

By the end of the 1920s, the Mersey was no longer the major route to the North Atlantic, having been surpassed by Cunard's liners from Southampton: *Lusitania* and *Mauretania*. The White Star Line operated its Olympic-class liners *Olympic*, *Titanic* and *Britannic* in direct competition to Cunard. *Titanic* was lost on her maiden voyage and *Britannic* sank in 1916 when she struck a mine. The failing White Star Line, a component company of the International Mercantile Marine Co. (IMM) shipping trust, was sold to the Royal Mail Steam Packet Company (RMSPC). The IMM trust, which lasted until the early 1930s, had seriously overstretched its finances and had fallen into rapid decline. In the meantime, the 1930s and the Great Depression had caused both Cunard and the White Star Line serious financial difficulties and a merger was brokered by the British Government in 1934 to save the two ailing companies. By 1947 Cunard had bought out the remaining share of the White Star Line.

The zenith of the Golden Age of the Atlantic super liner moored at the Liverpool landing stage was probably between the two world wars and ended with the decline of the North Atlantic passenger trade and the dawn of transatlantic air travel in the early 1960s. The liners finally departed from the Liverpool landing stage, otherwise known as Prince's Landing Stage, at the beginning of the 1970s when the massive Floating Landing Stage was demolished and a new and shorter stage took its place. Not all passenger services have been lost; the Isle of Man Steam Packet

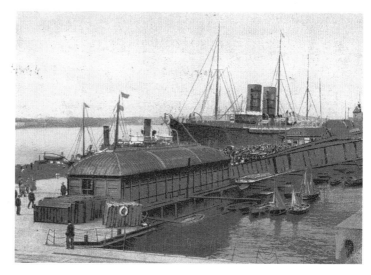

Co. operates a regular service and passenger cruise ships occasionally berth at the floating stage.

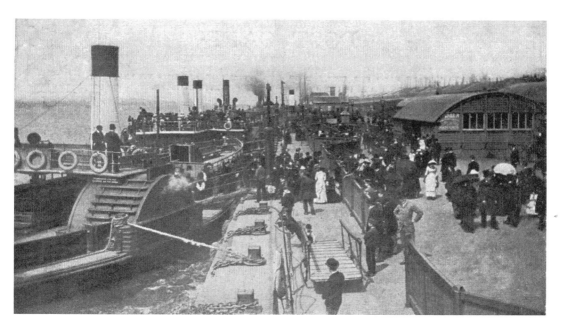

A view of the busy Liverpool landing stage. Introduced in 1815 PS *Etna* was the first steam-powered paddle ferry on the Mersey. It was shortly followed by PS *Vesuvius* and by 1840 all the ferry terminals on the Wirral and Liverpool were using paddle-steamers to cross the Mersey. The greatest advantage to passengers was in the ease and comfort that the crossing took, and that the ferry could run to a published timetable. The last paddle-steamers on the Mersey disappeared with the closure of Eastham Ferry in 1929 and the first coal-fired screw steamer, *Crocus*, appeared in 1884. Steam power disappeared altogether with the introduction of diesel-powered ferries which progressively replaced the steamers in the 1950 and '60s – perhaps the most famous of which was MV *Royal Iris*, which came into service in 1951.

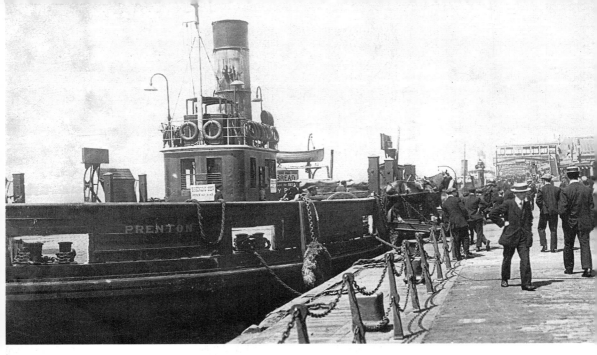

The luggage boat *Prenton*, seen here on 13 July 1913, was designed to carry vehicles and goods across the Mersey. Similar boats operated from Seacombe Ferry between 1879 and 1947 and Woodside from 1879 to 1940. SS *Prenton* was built by the Caledonian Shipping Co. in 1906 and operated on the Mersey ferry crossing to 1934 (see page 78). In appearance, she was similar to an open sardine can, but with substantially larger dimensions of 130ft length, 45½ft breadth and 13½ft depth and a gross tonnage of 487. Capable of carrying twenty delivery lorries or thirty carts, *Prenton* was withdrawn from service on the first day of the opening of the Mersey Road Tunnel. Both the Woodside and Seacombe to Liverpool services ended in the 1940s.

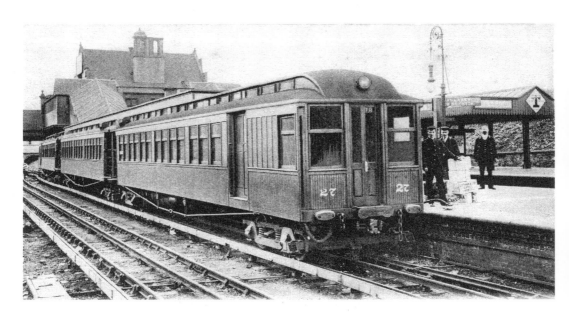

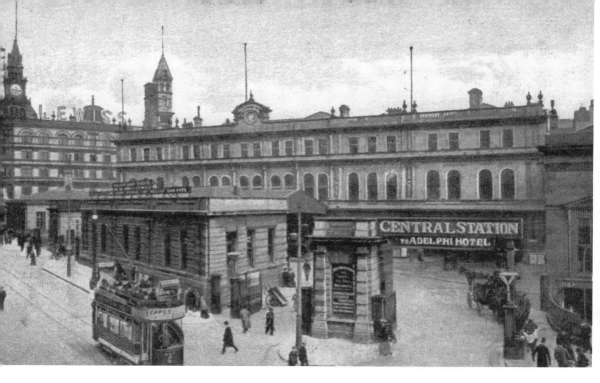

Liverpool Central station on the CLC opened in 1874 and closed on 17 April 1972. On the left is the Adelphi Hotel. Liverpool Central Low Level on the MR served the CLC station from 1892. Closing for a time in the mid-1970s, it was reopened in 1977.

Opposite: The first viable alternative to the ferry crossing of the Mersey came from the railway tunnel under the river. The Mersey Railway (MR) soon brought about the decline of the passenger ferry service, and the final pressure came from the opening of the Mersey Road Tunnel, which put paid to the transportation of vehicles by the Wallasey and Seacombe services. The tunnel was completed in 1885 and connected James Street station to Birkenhead. The line came to the surface at Green Lane, Tranmere, and a branch ran from Hamilton Square to Birkenhead Park. The line was steam powered when it was opened in a ceremony on 20 January 1886 and from the outset the control of foul air gave the company an operational problem, which fortunately was resolved when the line was electrified in 1903.

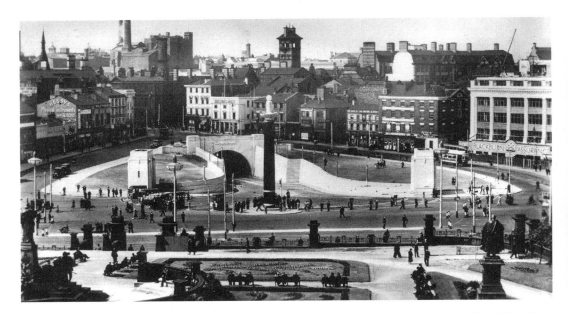

Two road tunnels also cross underneath the Mersey; the first, the Queensway Tunnel opened in 1934. Ferry services immediately suffered owing to the loss of millions of passengers in the first year of the tunnel's operation. The opening of the second, the Kingsway road tunnel, brought the Mersey Ferries to a crisis point.

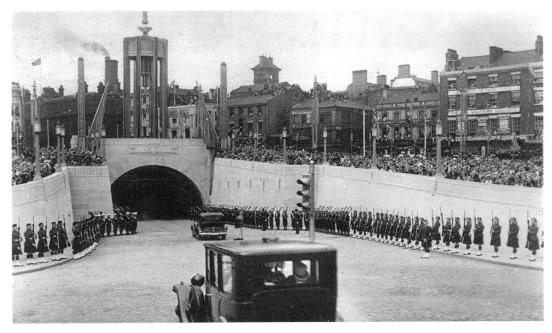

The opening ceremony of the Queensway Tunnel (Birkenhead tunnel) with an inaugural trip through by HM King George V. The tunnel started to show the strains of traffic in the late 1960s, which resulted in the cutting and building of a new route, the Kingsway Tunnel (Wallasey tunnel), which was opened in 1971 by HM Queen Elizabeth II. The opening of the second Mersey tunnel immediately prompted the closure of the New Brighton Mersey ferry.

Over 1 million tons of clay and river gravel was dug and rock cut in the construction of the semi-circular tunnels that comprise the main Queensway Tunnel. It took nine years to construct the 2-mile tunnel under the Mersey, which for over twenty years was the longest underwater tunnel in the world. A branch tunnel also emerges onto the Strand in front of the Royal Liver Building at a road exit beside the Our Lady & St Nicholas Church.

After the First World War, the dominance of Britain as an international trading nation started to decline in the face of foreign competition. This decline adversely affected Liverpool, the country's second largest port. Although important as a port for both passengers and cargo up until the middle decade of the twentieth century, Liverpool's fortunes began to further decline after the Second World War. By the mid-1980s, the decline had worsened with the closure of all conventional cargo facilities and the port had practically become silent – though the notable exception was the container and tanker trade. The loading and unloading of ships at wharves using dockyard cranes was a scene from the past.

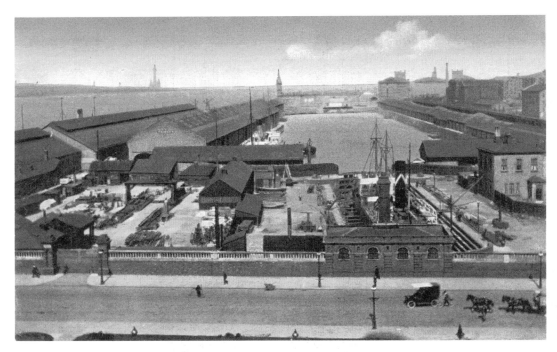

The dock estate alongside the Liverpool waterfront divides into southern and northern docks at Pier Head. The northern docks extend beyond the wall of Princes Dock and its graving dock, seen in the foreground. On the left is Riverside station, operated by MD&HB. The MD&HB, at the height of its success, operated over 7 miles of docks along the Mersey waterfront and employed 30,000 men. The docks basin north of the Pier Head remain largely intact, but all of the buildings seen here have been replaced by office blocks and a hotel complex which stand on what is now Princes Parade. The dock now forms part of the Leeds & Liverpool Canal.

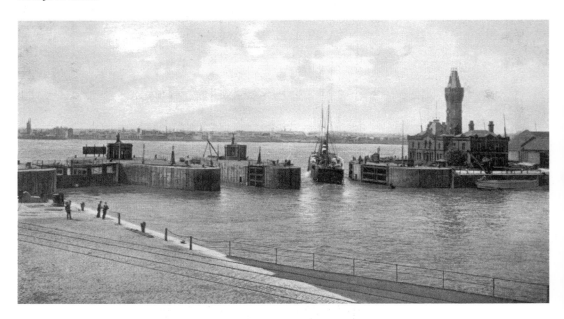

Princes Dock opened on the same day as the coronation of the Prince Regent as George IV in 1821. The brig moored at Princes Dock is a reminder of the time when trade in cotton, sugar, timber and grain was as important to Liverpool as the ocean liners and steam packet services. The dock here no longer sees the Dublin packet or trading ships, but remains navigable to canal boats.

Opposite: The entrance to Princes Half-Tide Dock, which opened in 1821. The dock serviced ocean liners and the Dublin and Isle of Man steam packet. Much of the dock estate has been redeveloped and the dock gates stand behind an office block at the corner of Princes Parade and William Jessop Way – named after the civil engineer William Jessop (1745–1814). A few rails remain embedded in a cobblestone forecourt as a feature – once part of the old wharf – to show where the former MD&HB railway crossed. The accumulator tower, which stood to the north of the river lock gates at the entrance to the Mersey, was demolished in the late 1940s to make way for dock improvements.

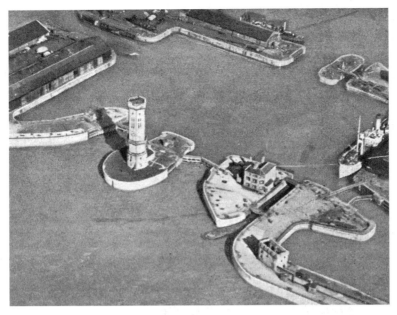

The dock entrance and navigation clock of the hexagonal-faced Victoria Tower at the entrance to Salisbury Dock. The building stands on an island formed by the riverside locks and today is abandoned and neglected; although it is part of the Stanley Dock Conservation Area, its future is uncertain. The gothic tower was yet another building designed by Jesse Hartley. Completed in 1848, it came to be known as the 'Dockers' Clock'. The clock faces now all show different times and mariners departing the Mersey have long since ceased to use it to set their chronometers.

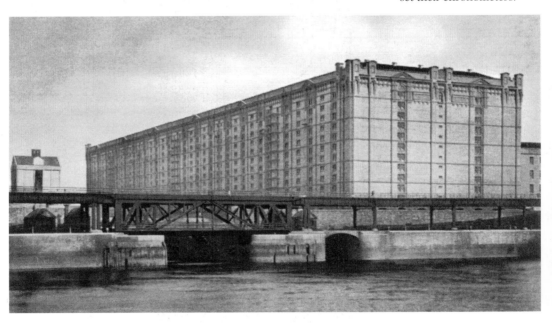

The 1901 impressive tobacco warehouse at Stanley Dock is Grade II listed and was constructed using over 25 million bricks (primarily yellow, grey and red russet). Decaying and falling into ruination with many of its 30,000 panes of glass smashed, the outcome for this building is uncertain. The structure on the left is the Tomkins & Courage grain silo. Vessels had to pass consecutively below the LOR and dock road under two bascule bridges. The combined LOR and MD&HB dock railway lift and swing bridge, along with both railways, have long since disappeared but the Regent Road drawbridge is still in situ, though in a derelict condition. It no longer carries vehicles, although it remains open to pedestrians.

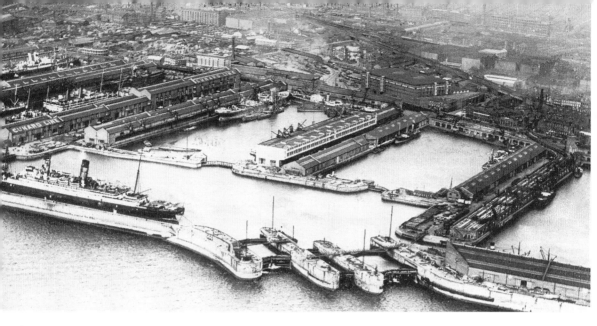

The entrance to Sandon Half-Tide Dock. Opened in 1850 and enlarged in 1901, it connected to Stanley-Moore Dock, which in turn connected with Nelson Dock (both to the south). Wellington Dock and Sandon Docks had separate tidal gates and the wharves and warehouses were used by Atlantic passenger liners.

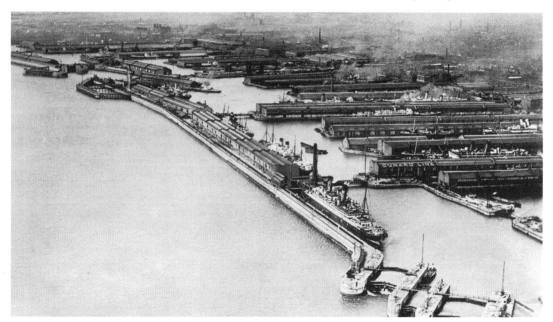

An aerial view of Sandon Dock, home to Cunard and the New Zealand Ship Co. Beyond the liner is Huskisson Dock, opened in 1852 and reached by a 90ft wide gate from the Sandon Half-Tide Dock. In the distance is the Canada Basin, which connected to Canada Dock by a 100ft wide lock. Canada Dock also had three branch docks and a large graving dock, while Canada Basin also connected to the northern Langton Dock by two locks both 65ft wide. Brocklebank Dock spanned between Langton and Canada Docks and connected to each from two separate sets of locks.

Jesse Hartley (1780–1860) was Civil Engineer and Superintendent of the docks from 1824 up to his death. Responsible for many docks and harbour buildings, the Huskisson Docks complex, designed by him, opened in 1852. Huskisson Docks handled timber and grain from North America and the view here shows one of the three branch docks. It was in Huskisson Branch Dock No. 2 that the SS *Malakand* of the Brocklebank Line was set alight on 3 May 1941 during a Luftwaffe air raid. The docks experienced the single worst event of the Liverpool Blitz when the burning ship, which was fully loaded with munitions, exploded and levelled the entire dock.

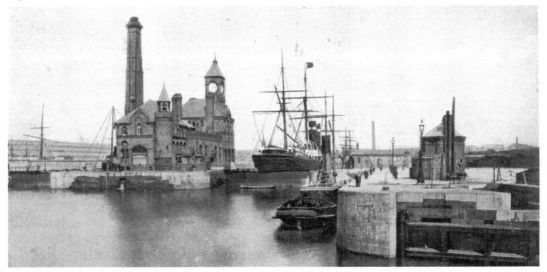

The gates here at Langton Dock, built in 1881, once opened onto No. 1 and No. 2 graving docks. The gothic tower and pump building also remain albeit in an appalling condition fenced off from the Liverpool–Belfast ferry lorry park which now occupies the former graving docks.

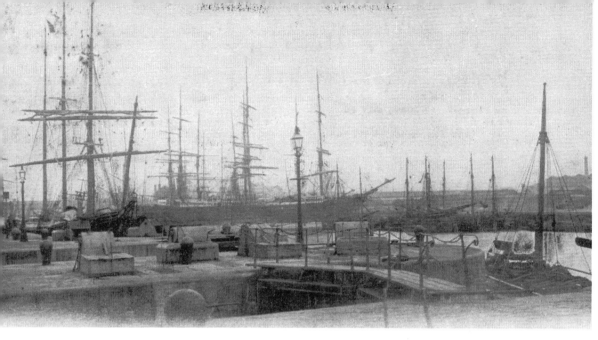

Brocklebank Dock, Bootle, was built in 1862 and at first was called Canada Half-Tide Dock. The dock connected with both the Canada and Langton Docks and was renamed Brocklebank in 1879 in honour of the former chairman of the MD&HB, Ralph Brocklebank. This group of docks underwent extensive improvements in the late 1960s with the addition of a new, enlarged river entrance and gates into Langton Dock.

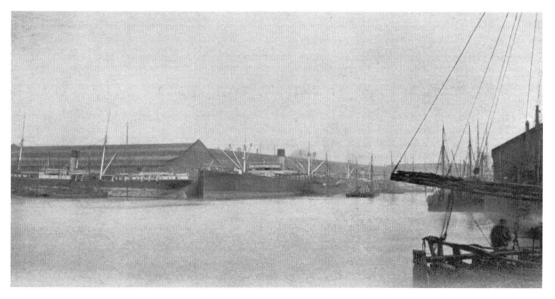

Bootle was once a large village a mile east of the Mersey on the Merton and Litherland turnpike road. By the mid-nineteenth century, the docks had begun to expand northwards from Liverpool and the village started to grow into a suburb of the city. Alexandra Dock was the most northerly dock built in the late nineteenth century; one of the three east-facing branch docks of Alexandra Dock is seen here. By then Bootle was totally absorbed into the suburbs of Liverpool with well-established transport links to the city by the railways, LOR and trams.

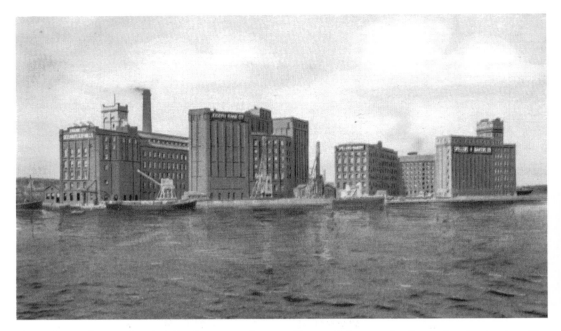

Alexandra Dock opened in 1881 and was once home to Liverpool's huge grain silos and grain elevators. The north of the dock was home to Union Cold Storage refrigerated warehouses and importers of frozen meat. The Strand Road entrance to Liverpool Free Port joins Regent Road (the dock road) and passes the former Harland & Wolff foundry building, but the site has now been cleared of these massive multi-storey warehouses.

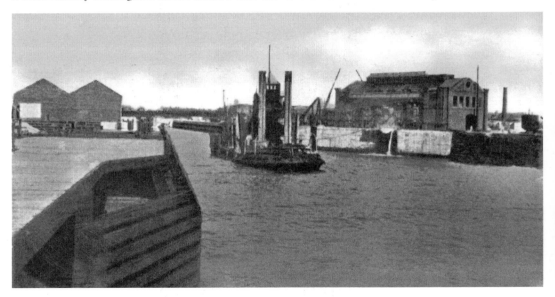

Gladstone Dock, built in 1913, was at the time the furthest expansion of Liverpool's northern docks. The docks have today expanded further north to the Royal Seaforth container terminal opened in 1971, with access from Gladstone Lock. The Liverpool Freeport Zone established in the mid-1980s over the northern docks and the establishment of the Euro terminal at the newly built Seaforth Docks, resulted in a significant expansion of trade for Liverpool and the Mersey.

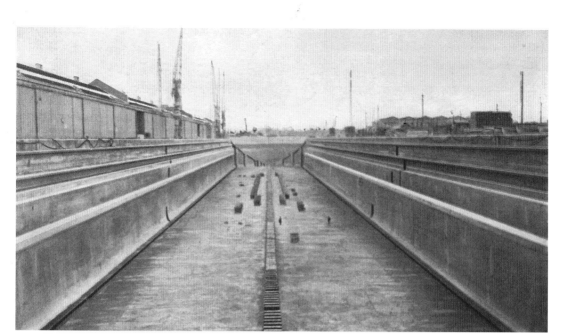

The Gladstone Graving Dock, built for the maintenance and repair of ocean-going passenger liners, was converted to a wet dock and is called Gladstone No. 3 Branch Dock. It serves as the roll-on, roll-off terminal for P&O Irish Ferries. Royal Seaforth handles modern container ships and bulk carrier vessels for grain and animal feed. Part of the new port is used for transporting scrap metals and coal.

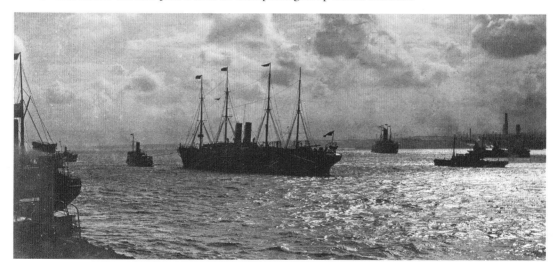

At the start of the eighteenth century, Liverpool was little more than a small sheltered inlet on the Mersey, but within a couple of centuries it had grown into one of the greatest ports in the world. Liverpool's docks extend over 7 miles along the eastern shore of the Mersey Estuary. Seaforth is the most northerly point of the docks, and from here, the navigable Crosby Channel takes the River Mersey into Liverpool Bay and the Irish Sea. This deep navigable shipping channel between the Mersey and the open sea led to the success of Liverpool as a port, while Chester, the principal rival north-west English port on the River Dee, declined because of heavy silting of its navigable channels.

The navigable Crosby Channel in Liverpool Bay and the Mersey Estuary allowed ever-larger ships to reach Liverpool. The channel flows northwards past the shifting sandbanks of Formby Bank and dunes between Seaforth, Waterloo and Blundellsands across the mouth of the River Alt to Formby Point. The sands below the Formby Hills and the beach at the mouth of the Mersey Estuary were a popular attraction to Liverpudlians seeking escape from the dirt and grime of the city.

A final glimpse of the Mersey and Liverpool Bay as the Mersey merges with the Irish Sea.

5

EGREMONT TO
NEW BRIGHTON

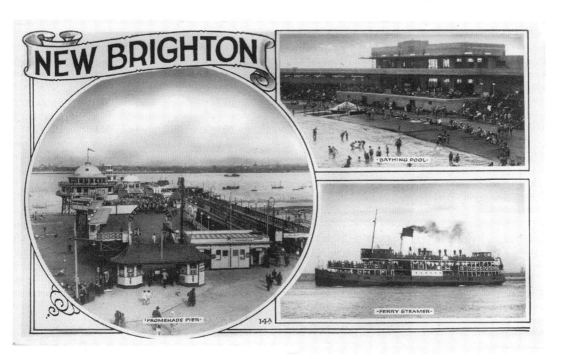

This multi-view photographic postcard shows scenes of the entrance to Promenade Pier, the bathing pool and the Wallasey ferry approaching New Brighton. *(Publisher unidentified)*

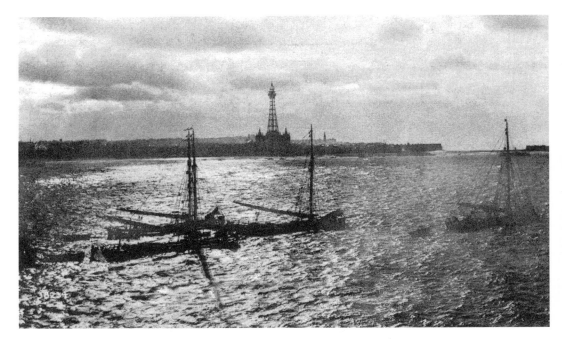

This view is of New Brighton in the early twentieth century from the widening Mersey Estuary. On the right is Fort Perch Rock at the extreme northern tip of the Wirral, beyond which stands the New Brighton Lighthouse. The New Brighton tower dominates the shore.

The Wallasey promenades of the east shore of the Mersey extend 2½ miles northwards to New Brighton. From the Seacombe ferry, the Seacombe Promenade runs for half a mile to Egremont, passing the huge ventilation tower of the Wallasey road tunnel and the Mersey-facing Wallasey Town Hall to meet the extinct Egremont ferry terminal seen here. Egremont Ferry quay has the pub named after it and Speakers Corner is a pleasant spot to take in the view across the Mersey towards Liverpool or north along Egremont Promenade.

Looking north along Egremont Promenade we see the famous Mother Red Caps Inn, one-time haunt of fishermen, sailors and privateers and a hiding place from the press gang. It was demolished in the 1970s to make way for an old people's rest home.

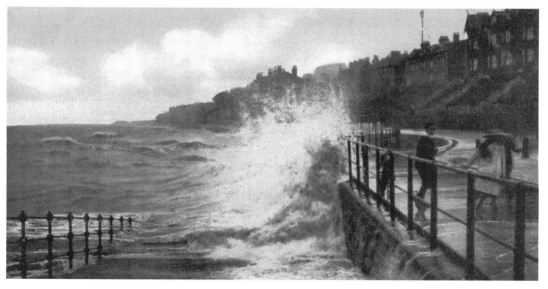

Egremont acquired its name from a villa owned by Liverpool Harbour Master, John Askew, who commuted across the Mersey each day on his own private boat, which was also hired out to others as an unofficial ferry. In 1830, Askew purchased ferry rights, built a 200ft long wooden pier and a quay, and operated a steamer ferry. Two additional paddle-steamers were purchased in consecutive years to run an hourly service. The ferry service was frequently suspended when his vessels undertook more lucrative towing work in the river. Because of his official position and vested interests, Askew was forced to relinquish control of Egremont ferry, which he sold to the Egremont Steam Company in 1835. The ferry then changed hands a number of times, ending up in 1849 with the Coulborn Brothers, who were the owners of the New Brighton ferry. Egremont and New Brighton services were then combined. In 1861 the Wallasey Local Board bought out the privately owned ferry.

On top of the hill on the left, away from the promenade, is the narrow Pengwern Terrace. This leads to the Magazine pub, further along the Magazine Brow, which passes beside old fishermen's cottages. There is another aptly named pub, the Pilot Boat, in the Mariners Road. The magazine was used to store gunpowder deposited by visiting vessels to prevent it being a hazard when taken into the port. The crenulated walls of the old magazine can be traced in the garden walls of houses built in Magazine Brow.

The entrance to Vale Park. Some of the formal gardens remain, but the park today proclaims itself to be a community resource, with a children's play area, barbecue and five-a-side football pitch. Owned by Wallasey Council, the park is also cared for by local residents.

The ornamental garden at Vale Park, with, rising over the Victorian villas, the New Brighton Tower alongside Magazine Promenade and the Mersey. Only a grassy area known as Tower Grounds remains on the site of the former Tower Ballroom and tower. The New Brighton Tower – modelled on the Eiffel Tower – was built in 1900, ten years after Blackpool Tower, and stood 567ft high – almost 50ft taller than Blackpool Tower. At the time it was the tallest structure in the United Kingdom.

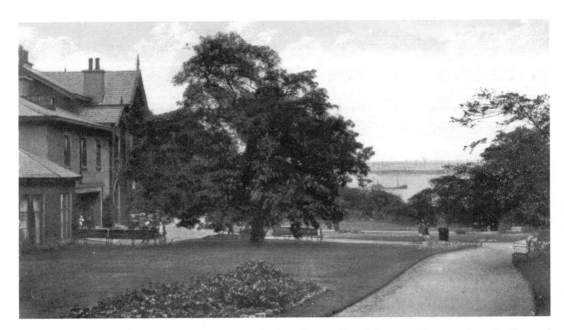

Liscard Vale was an exclusive late Victorian and Edwardian residential area with a number of villas and two large mansions, Liscard Vale House and Liscard Vale Hall, which was renamed The Woodlands to avoid confusion with the former house. Liscard Vale House and grounds were sold to the Urban District Council in 1909 and used as a municipal golf links. The house seen here still survives and was used for a time as a café for visitors to the park. Woodlands House was demolished but the grounds, also purchased by the Urban District Council, were combined with the grounds of Liscard Vale House to form Vale Park.

The bandstand, Vale Park, 1930s. Fortunately it is still used nowadays for brass bands, musical events, rock concerts and talent shows. Liscard Vale House, after lying derelict, has become the park's community centre.

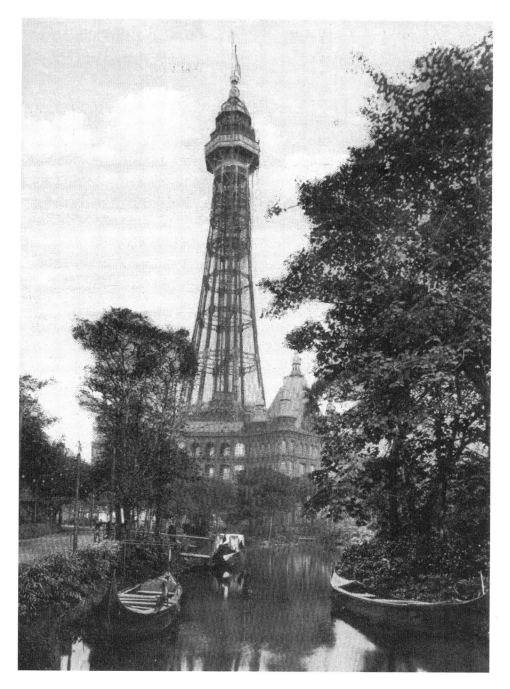

The 30 acres of Tower Gardens included a lake on which Venetian-style gondolas carried passengers, as well as a Japanese lakeside café. In the nearby old quarry were a fountain, seal pond and a Parisian Tea Garden restaurant. At the promenade was an outside dance floor and bandstand. During its final years, a miniature railway ran around the old quarry from the amusement park and fairground entrance.

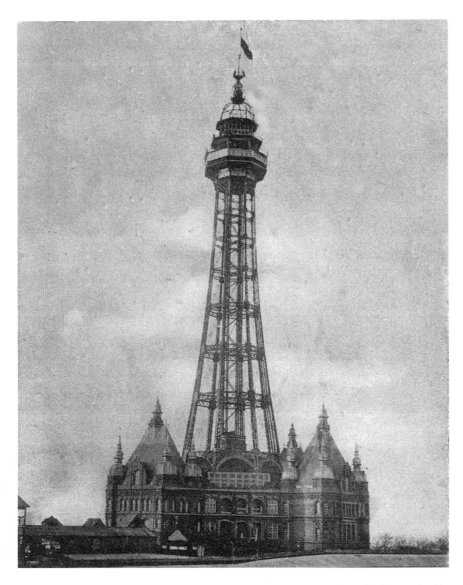

Wallasey and New Brighton's greatest attraction was the tower and pavilion, built specifically to attract workers from Lancashire and the Midlands for their holidays and days out. Completed in 1900 the steel tower, weighing over 1,000 tons, had been dismantled by 1921 owing to its dangerous and neglected condition.

Opposite: An aerial view of the pavilion minus its tower. Lord Leverhulme opened New Brighton swimming pool in 1934, and within the first four months over one million people had passed through the turnstiles. The pool occupied an area of 4½ acres constructed of reinforced concrete and rendered in white Portland cement skirted with black ceramic tiles. Built to championship and international standards, the structure was sheltered by a large sea wall and the pool was filled with filtered and treated water from an ornamental cascade. The first Miss New Brighton contest started in 1949 and the last contest was held here in 1989. The pool was badly damaged by severe storms in 1990, and was demolished.

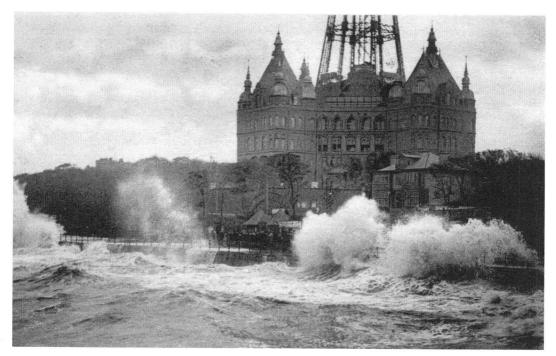

An October gale in 1905 at the pavilion. The dismantling of the tower started in 1919 and had been completed by 1921. The lavishly decorated ballroom and theatre remained. The sprung dance floor and its stage were large enough for 1,000 couples, and the ballroom was one of the largest in the world.

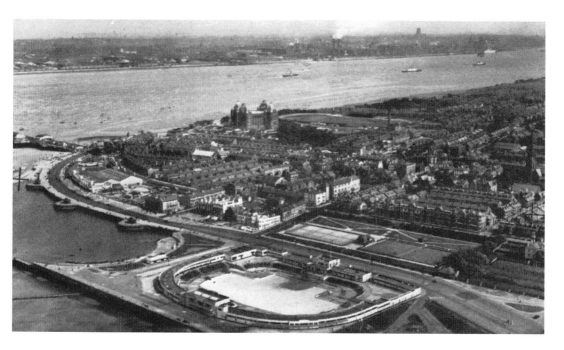

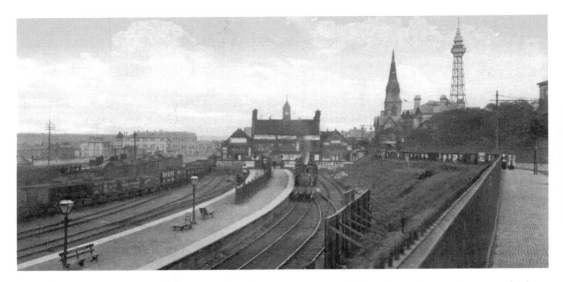

English seaside resorts expanded in Victorian times as a new social class began to experience sea bathing – among them middle-class clerks, shopkeepers and later the industrial working class. The working class relied in the main on Sunday School and employers' excursions. In the latter part of the nineteenth century, this changed and Lancashire textile workers began to take Wakes Week holidays, and bank holidays, which developed into the traditional northern working-class seaside holiday. The established middle-class resorts struggled to cope and many resorts, including New Brighton, experienced their greatest period of growth as a result. The Seacombe, Hoylake & Deeside railway (SH&D) extension to New Brighton became the main artery delivering the flow of working-class visitors. The extant station opened in 1888.

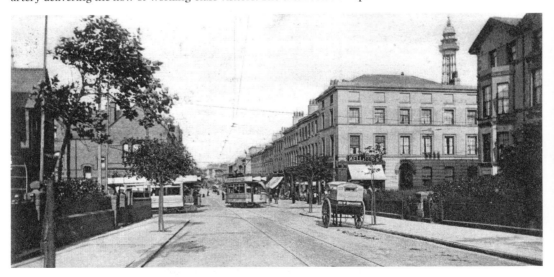

In 1830, Liverpool merchant James Atherton purchased 170 acres of land at Rock Point overlooking the north-east shore of the Wirral Peninsula with the intention of turning it into a bathing resort and selling plots for seaside residences to the nobility and gentry. Issuing a prospectus for investors, he and his associates decided on the name New Brighton. Within a few years, New Brighton had developed as a competitive resort and a large coastal town. The view shows Victoria Road at its crossroads with Rowson Street. Some of the buildings have been demolished, otherwise the scene is still recognisable.

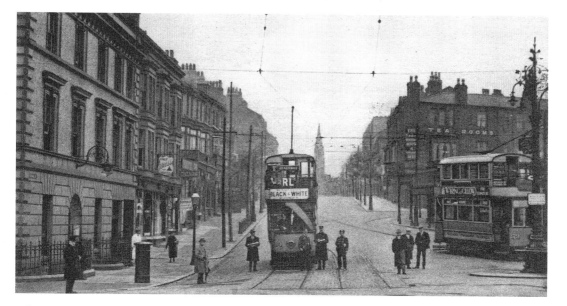

Atherton's prospectus claimed that each new property would have uninterrupted views of the sea, and elegant villas were indeed built along the Wellington Road and adjoining roads with views of the north coast and Mersey Estuary. This second view of Victoria Road is looking up from Marine Promenade and Tower Promenade. On the left today is the Red Cap pub, an echo of the old Mother Red Caps. By the end of the nineteenth century New Brighton was a large, well-established town with a well-developed infrastructure of railways, ferry services and a local tramway network.

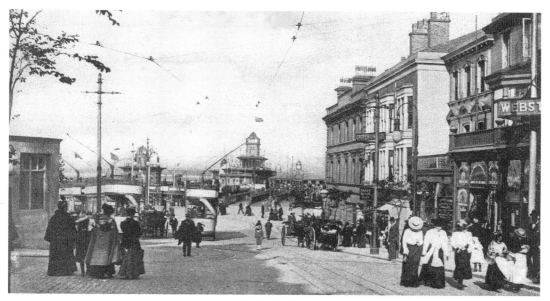

Looking back from the crossroads of Virginia Road and Victoria Road in the opposite direction from the previous view. The Wallasey Corporation Tramways system opened in 1902 and utilised extended routes of the former Wallasey Tramways horse-drawn system. The trams were withdrawn in 1933 after the service was run down and replaced by a council-operated bus service.

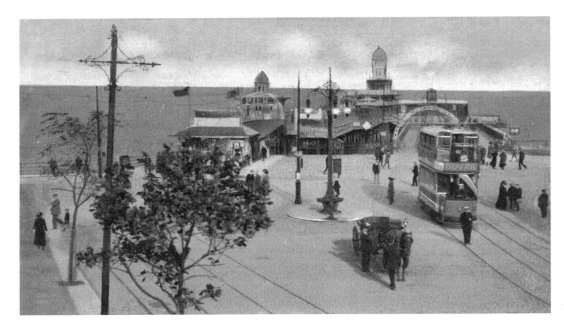

A one way-loop on the Wallasey Corporation Tramways' New Brighton route served the ferry and promenade piers. The system had extensions to Upper Brighton from Egremont and Liscard via Wallasey. By the end of the nineteenth century, the easily accessible resorts like New Brighton were attracting thousands of working-class visitors and holidaymakers. This mix of the classes changed New Brighton's character from a resort catering for the nobility, gentry and middle classes forever.

Side-by-side, the busy pier head and ferry pier in the 1930s. Sadly neither still exist; passenger numbers had declined through the 1960s and the last commercial ferry berthed at the stage in 1971. The pier also suffered a similar decline of patrons and it was demolished in 1978.

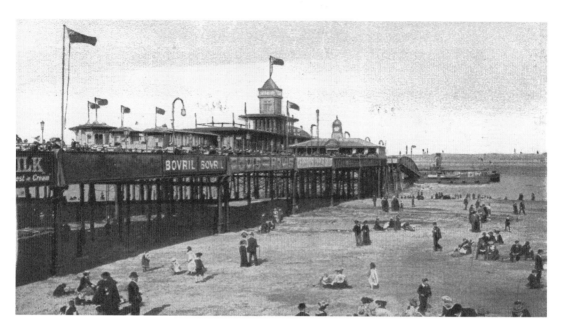

The pier and a ferry visiting the floating landing stage at low tide in the first decade of the twentieth century. From the 1830s, a wooden pier extended out into the Mersey so the ferry could berth at low tide. In 1860, the local board purchased the ferry and pier and rebuilt it as an iron structure. From 1868, the pier was operated by a privately owned passenger ferry company, which charged an admission charge of *2d* to enter the promenade pier from the ferry stage. This pier was 550ft long and 70ft wide, with refreshment rooms, a bazaar, bandstand and a seated promenade area as well as a telescope viewing area overlooking the Mersey. In 1899 the shore promenade was extended to the pier heads and the ferry and pleasure pier entrances became separated.

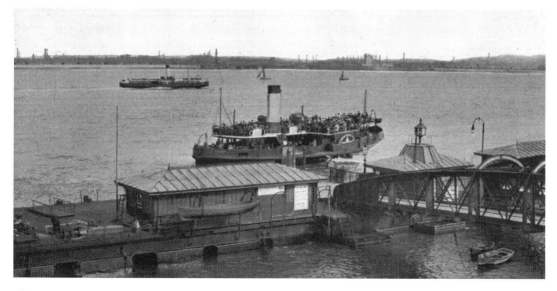

The New Brighton floating landing stage was swept into the Mersey Estuary during a gale on 16 March 1907, when it was torn from its moorings. It was later salvaged and reconnected to the ferry pier.

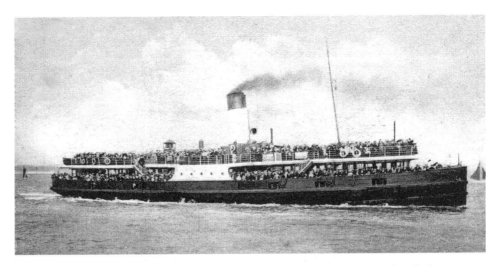

An unidentified Wallasey steam ferry approaching the landing stage loaded with day-trippers eager to sample the delights of New Brighton.

Two new Wallasey ferries, *Iris* and *Daffodil*, came into service in 1906. Both vessels were requisitioned by the Admiralty for a naval raid on Zeebrugge and Ostend on 23 April 1918. Here we see SF *Iris* after the raid. King George V granted Wallasey Corporation permission to prefix 'Royal' to both vessels' names in recognition of their part in the raid. A less reverent but affectionate nickname for Wallasey ferry MV *Royal Iris* (1951) was the 'fish and chip boat' because of her onboard fish and chip café, later a steak bar. She was better known as a cruise boat and a venue for Liverpool's best-loved bands, which probably earned her another nickname of 'booze boat' and 'love boat'; the vessel is now sadly languishing at a wharf in Woolwich.

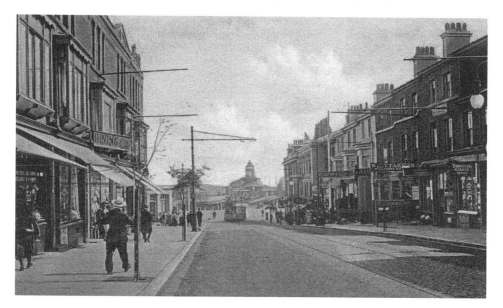

Two views of the pier head end of Victoria Road. Here we see Whitaker's Tea & Dining Room and Webster's Refreshment Rooms on the right. There are numerous tea and dining rooms and pubs on either side of the street. Visitors arrived by tram and ferry or made their way down from the MR (formerly SH&D) station along Victoria Road.

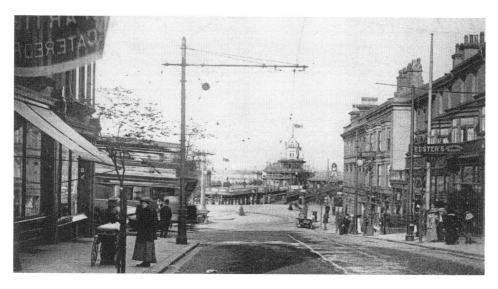

Victoria Road again in a former more affluent age when the town was a major coastal resort. The Wallasey Corporation Tramways tram has just passed over the pier head one-way loop and is heading into Virginia Road. In recent years, there has been a concerted effort by the council, developers and local residents to revitalise New Brighton as a resort and desirable destination for visitors and residents, after many years of neglect and decline. Local partnerships have proposed founding a heritage and information centre on Victoria Road to inform residents and visitors of the local history of the area.

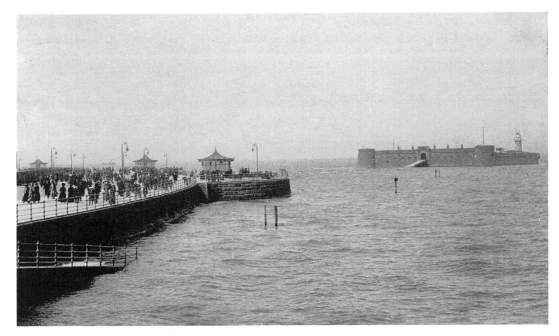

During the early nineteenth century, Liverpool merchants and the port of Liverpool authorities were concerned that the docks were undefended from potential raiders. Because the old Perch Rock Light was also constantly being washed away in bad weather, a fort and lighthouse was proposed to solve both issues. However, the fort and light were built separately. Built of sandstone the fort occupies an area of 4,000sq yards and the walls are 24ft thick and 30ft high with four 40ft towers at each corner. The fort is cut off from the shore at high tide.

New Brighton Fort and the sands exposed at low tide. The fort stands at the mouth of the River Mersey in full view of shipping passing 950 yards from the battery. Armed with eighteen guns most of which were 32-pounders, there was accommodation for 100 men and officers, a well-provisioned stores, armoury and powder magazine.

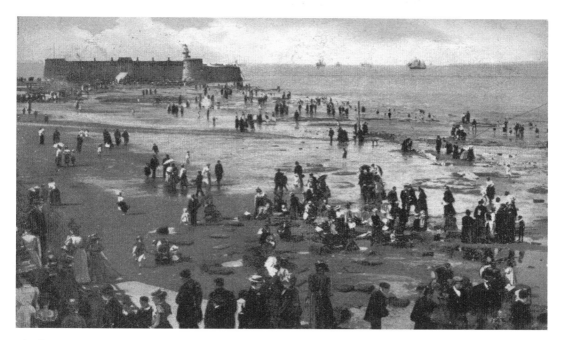

The fort stands on Black Rock, which is part of Perch Rock. The entrance to the castle is through a portal from a three-arch slipway and drawbridge (now replaced). The slipway is partially covered at high tide.

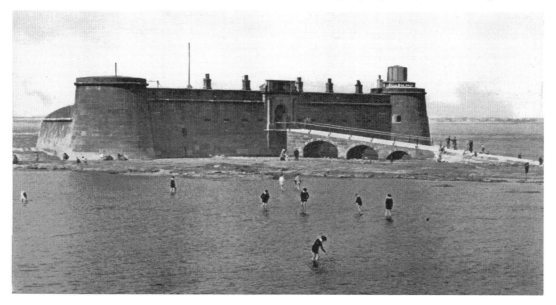

As the nearby Rock Channel silted and larger ships moved out to the deeper and more distant Crosby Channel, the range of cannon at the fort was increased with the addition of 64-pounders. At the outbreak of the First World War, the fort was equipped with a 6in gun and two machine-guns. The drawbridge was removed in 1935 and by 1954 the fort had been abandoned. Sold by auction in 1958, the fort for a time became the War Plane Wreck Investigation Group's museum. It has since been sold again and its future is uncertain.

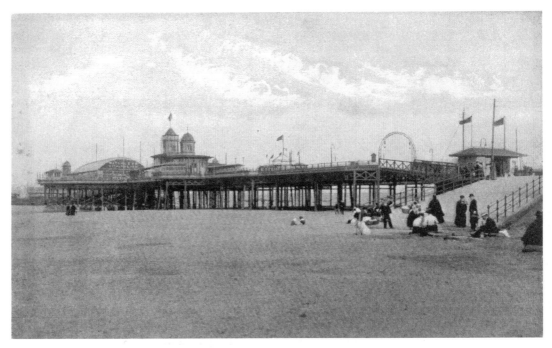

Two views of the pier in Edwardian times, from the north looking back up the Mersey Estuary . . .

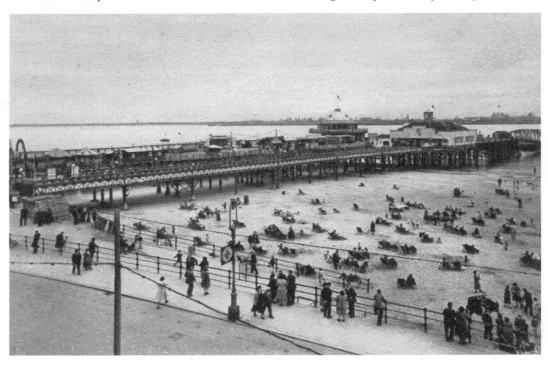

. . . and the pleasure pier and ferry pier from the south in the 1930s looking out towards Liverpool Bay and the Irish Sea.

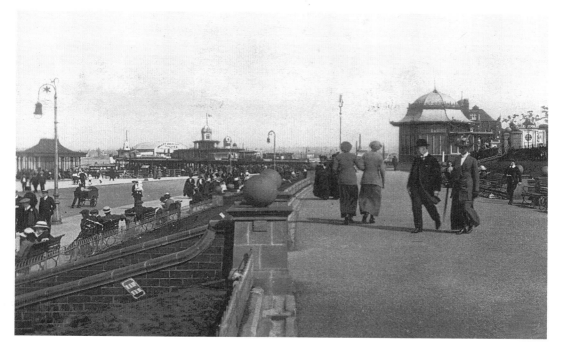

Victoria Gardens and New Brighton piers stretching into the Mersey have gone, but the surviving and easily spotted stone capped stairway continues to lead onto Marine Promenade.

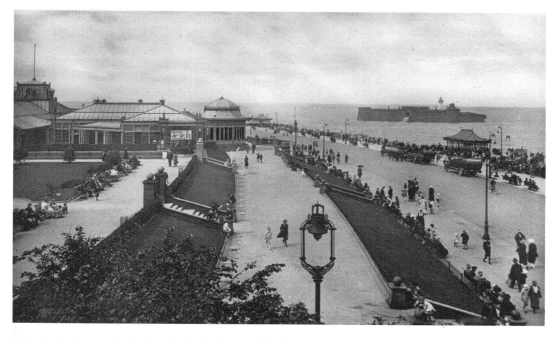

Victoria Gardens with the fort in the background looking out to sea and the old Floral Pavilion Theatre with its glass roof. The two terraces on the left remain, although the upper terrace is now a car park entered from Virginia Road.

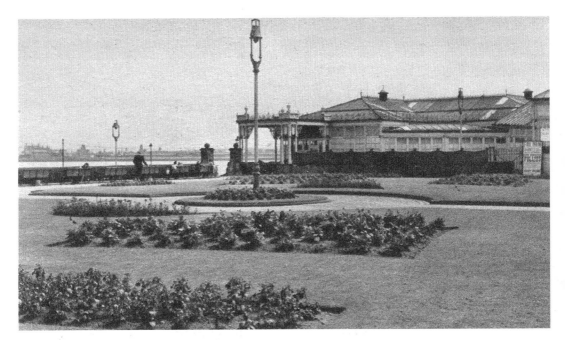

Overlooking the Mersey, Victoria Gardens opened on 3 May 1913 and comprised formal gardens and an open-air summer theatre known as the Floral Pavilion. In 1925, an iron-supported glass roof was erected around the open-air theatre. The roof was replaced in 1965, but in this century, the old Floral Pavilion was considered to have served its useful life and so was demolished in 2006. A newly built theatre and conference centre opened on the site in 2008. The first act to appear at the new facility was Liverpool's Ken Dodd.

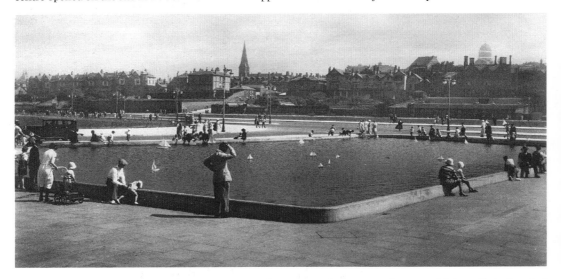

The boating pool at New Brighton was constructed in 1932. The New Brighton Model Boat Club, founded in 1981, used it for regular events and club members cleaned, repaired and generally looked after the pool to ensure that it remained a popular local attraction. Many model boats sailed here have a strong association with the Mersey. The old pool has been demolished, but a new purpose-built pool has been built on the promenade to keep the tradition of model boats alive in New Brighton.

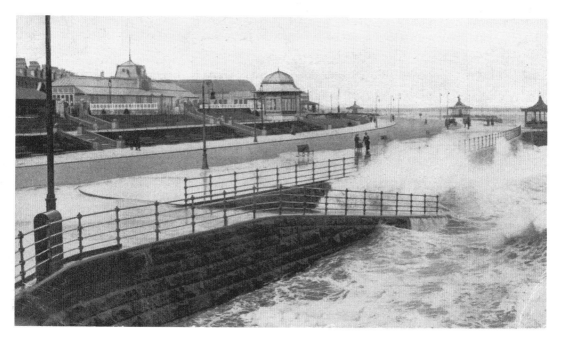

Two views of rough seas at the Marine Promenade. The promenade, built in 1873, joined onto the neighbouring Pier Promenade; above it was a terrace on which cafés, shops and an amusement arcade stood.

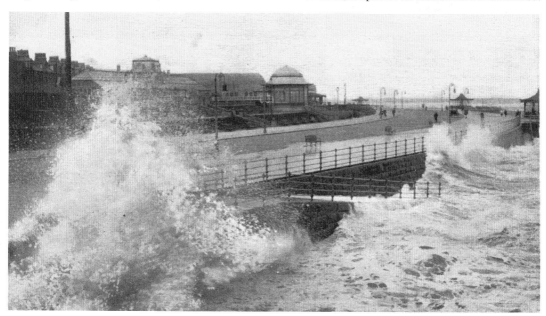

The terraces of Victoria Park were once part of the Aquarium Parade often referred to as the 'Ham and Eggs Parade' or even earlier as 'Tea Pot Row' since it was cluttered with numerous huts and cafés which served breakfasts and teas to visitors. The parade was so overcrowded that people were often jostled and pushed off the unguarded edge onto the sands. The old buildings on the parade were demolished to make room for the more spacious Victoria Park to be built on the site.

The New Brighton or Perch Rock Lighthouse at low tide. It stands at the most northerly tip of the Wirral Peninsula and the entrance to the Mersey. Perch Rock takes its name from the original light that was a post with lateral supports driven into Black Rock and supporting a wooden perch with a light. The constant need to repair and re-erect the Perch Rock light after each loss prompted the construction of a more permanent light. Thomas Littledale, Mayor of Liverpool, laid the foundation stone of the new lighthouse in 1827. The lighthouse stands 90ft above the rock, the first 45ft are solid, and the exterior stonework is coated with hard volcanic pumice. The lighthouse, completed in 1830, flashed twice white and once red, and last shone out on 1 October 1973.

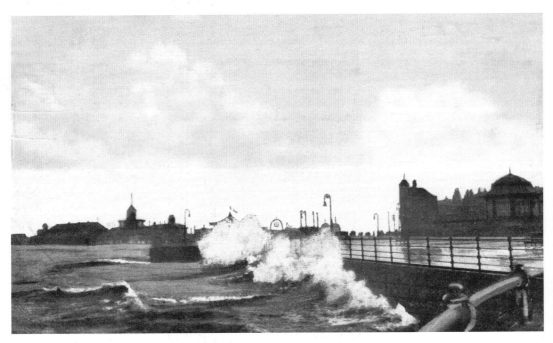

The ever-popular view of rough seas at New Brighton from the promenade beside Victoria Gardens. Today New Brighton offers a summer programme of seaside entertainment, from the traditional Punch and Judy to a range of business, community and charitable events. The local Wallasey Yacht Club also organise races on the Mersey and Wirral coast. The club, founded as the Magazine Sailing Club in 1903, moved to New Brighton in 1912. The boats are often moored on the Mersey, at the same spot as in this view, although they are taken in at the end of the season in September with the start of the autumn and winter gales.

A similar view to the previous one (opposite, bottom left). The view over the Mersey from this point is substantially changed; the two piers have gone and the Liverpool coast has more high-rise blocks, but a cold and wet Mersey spray can still be experienced from this same spot today.

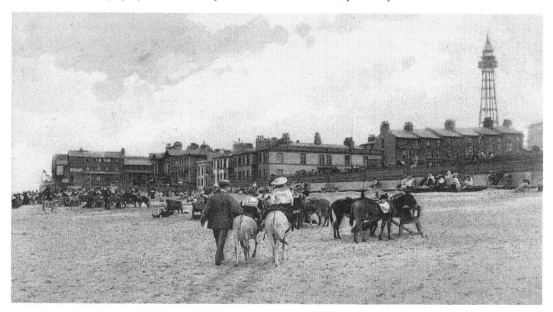

The northern coast of New Brighton with Rowson Street – today's A554 – running downhill towards Marine Promenade. This whole beach was once the site of New Brighton Swimming Baths. After the baths were demolished in 1990, the land remained derelict, but it has recently been developed as Wallasey Waterfront Retail and Leisure Park. The view shows Kings Parade, seaside cafés, the Queen's Royal Hotel and Darcy's pub.

The Red Noses, which once emerged onto New Brighton's sandy beach, were a favourite spot for bathers and picnickers in the early years of the twentieth century. In earlier times wreckers' and smugglers' tunnels supposedly stretched from the Red Noses inland throughout Wallasey.

The Red Noses are an outcrop of sandstone rocks alongside the Coastal Drive near to the metal sculpture of a clown that holds a 'Welcome to New Brighton' banner. The rocks are now overlooked by two high-rise tower blocks at the end of Wellington Road.

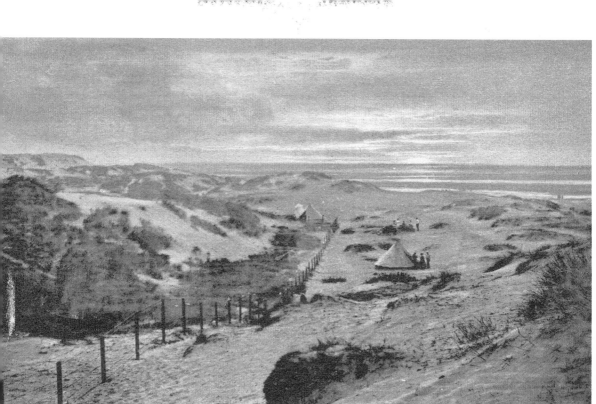

The Wallasey coast from New Brighton to Leasowe was notorious for wreckers and smugglers preying on Liverpool-bound ships. The mid-nineteenth century saw many ships wrecked during storms and treacherous conditions. Cargo which washed ashore was swiftly carted away or hidden, and whole ships were often plundered while they lay beached and stricken. Often the crimes were perpetrated by opportunist local inhabitants, but the deliberate wrecking of Liverpool-bound ships was also practised. The lighting of fires during storms gave mariners the impression of a safe port light, but instead lured their ships onto dangerous sandbanks and rocks at the edge of the Mersey Estuary.

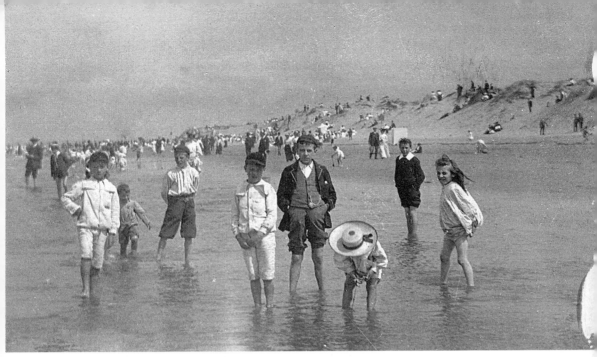

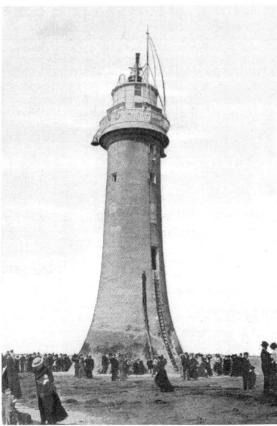

Above: Wading on the Wallasey shore is a very old tradition. Local folklore says that King Cnut (994–1035) sat on the beach here and famously commanded the tide to turn. These children and the hundreds of people behind them are making the most of the Wallasey sands and sea.

The end of our journey down the River Mersey is here, below Perch Rock Lighthouse where the river meets the Irish Sea.